U0040206

彩虹橋

★RAINBOW BRIDGE★

★寶總監 /著
By Director Bao

寶總監
Director Bao

知名圖文畫家。粉絲頁除了分享自己和秋田犬泥褲總裁之間的故事，更常無償代畫領養文、宣導文，受到廣大粉絲喜愛。

用漫畫或插畫的方式描寫人狗之間情感的深層面，經常會幫粉絲們寫與畫狗的認養文，希望能藉此幫那些無家可歸的狗找到一個溫暖的家，也希望能將這股感染力擴大，畢竟世界上的壞事太多了，需要更多善良的事和溫暖的人。

投入插畫後最大的樂趣和挑戰，即是每天都要畫不同的插畫或漫畫給粉絲們看，最大的心願是能夠讓愛狗的人越來越多，並繼續推動「領養代替購買、終養不棄養」的觀念，讓更多無家可歸的狗狗們都能找到最溫馨的家以及最愛護他們的人們。

出版作品：《總裁是個賠錢貨》、《黑道老大與他養的狗》（時報出版）

粉絲頁：寶總監與秋田犬泥褲總裁 Director Bao & Akita Niku Ceo
https://www.facebook.com/niku790305/

前言
Preface

首先感謝大家買了這本書，彩虹橋這個系列是要安慰寵物過世的主人們，其實離別並不是結束，而是另一個開始，只要讓愛繼續延續，最終你們必定會在生命的盡頭再度重逢，只要你願意去相信。

Firstly, I greatly appreciate your support for buying this book. The purpose of Rainbow Bridge Series is to relieve the owners whose pets have been gone. Separation is never the end.On the contrary it's another beginning. As long as your love goes on and on, eventually you will meet your beloved ones again at the end of life.

而之後的天使狗（接班狗）系列，會告訴大家，其實死亡並不會讓緣分斷掉，而是經由接班動物而延續下去（要出應該也是明年的事，彩虹橋就要搞死我了）。

There will be an Angel Dog (Successor Dog) Series which describes that death doesn't really cut the connection between dogs and their owners. Love will be extended via its successor dog, cat or any other pet. (The birth of Angel Dog Series will be scheduled next year if Rainbow Bridge becomes the bestseller . In addition, I'm freaking worn out because this book, I need a break.)

在此要感謝常常稱讚我的阿嬤，我霸氣的大姑和北爛的小姑，還有泥褲和我的配偶，感謝我出版社的編輯們，總監大梁哥，我的責任編輯晏璂，還有淑媚和米拉和我充滿野性的企劃莎賓娜王（我的編輯們都很低調不願意放名字真是莫名其妙），也要感謝幫忙支援英文翻譯的好狗友米粒和她養的狗小栗，以及給我印刷意見的大房威凱和二房盈鑌，還有帶給我歡樂的盈鑌的可愛老婆。

I would the to offer my many thanks to those who support me all the time. Thanks to my Grandma who always gives me plenty of compliments, my beautiful and proud Auntie Shuzhen, my lovely but nagging Auntie Shufen, Niku and my reliable spouse, my editors including Director Editor Spring Liang, Production Editors Joanne, Mei, Mira and my wild but talented Project Editor Sabrina Wang. (They are all low-profile people and resist their names to be mentioned in the introduction, such insane editors! Their names will be printed on the copyright page anyway.). Also, thanks to my dog-addicted peer Miely who helped me with the English part and her super cute dog Kuri. Never forget to mention my printing advisors Kai and Mark — I have officially selected them as my primary wife and secondary wife, and Mark's lovely, real, lawful wife who brings me endless joy.

最後要感謝一直支持我的小粉絲們，因為你們所以這本書才會生出來，希望這本彩虹橋能帶給你們力量，讓你們能夠繼續往前走，幫助更多需要幫助的動物，這才是這本書存在的意義和價值。

Finally, I would like to say "Thank you" to my genuine fans, you have been my best support since the very beginning, this book is created for you. I truly hope that Rainbow Bridge can bring you the strength which you have given to me, to keep you moving on and giving a hand to more animals in need. That's the true value and purpose of this book.

目錄
Contents

第一章
天使

Chapter 1
Angels

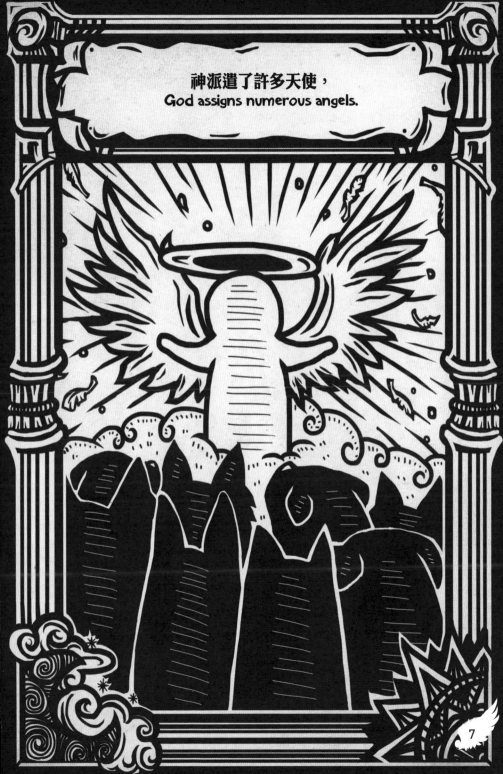

神派遣了許多天使，
God assigns numerous angels.

7

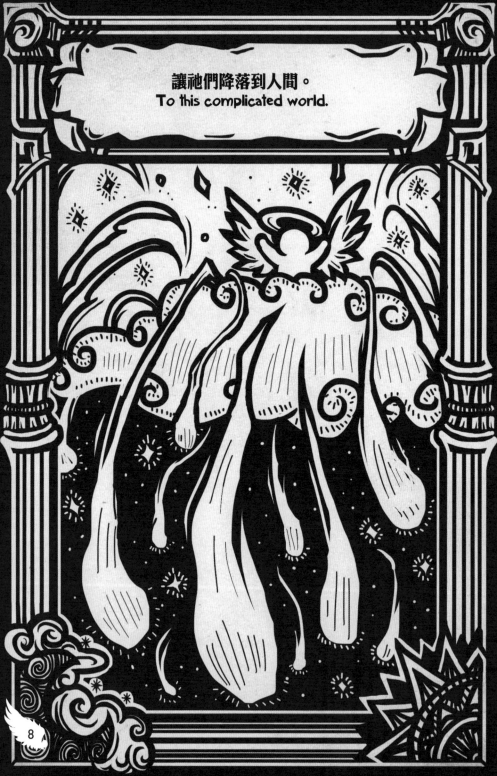

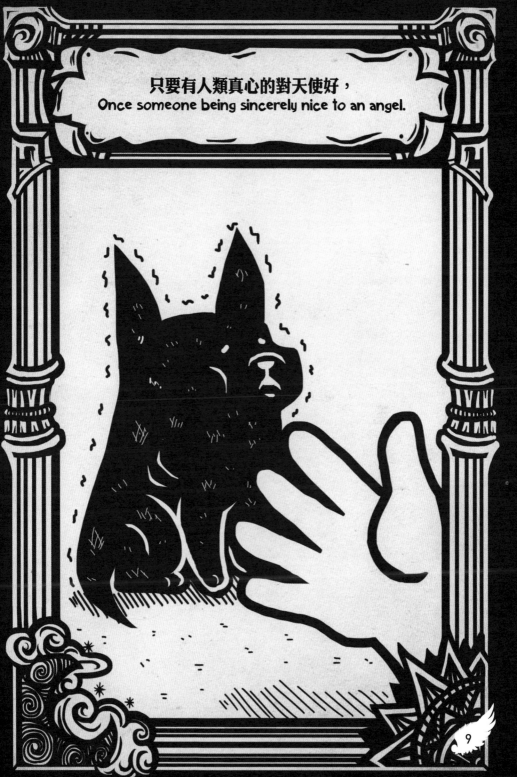

只要有人類真心的對天使好，
Once someone being sincerely nice to an angel.

9

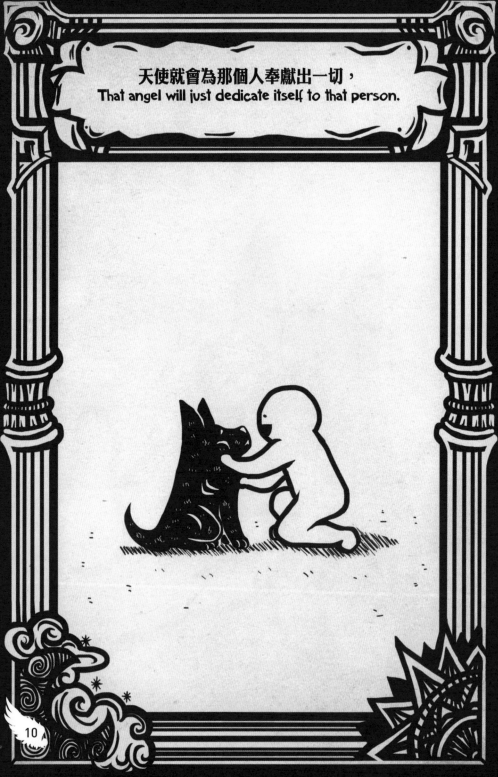

天使就會為那個人奉獻出一切，
That angel will just dedicate itself to that person.

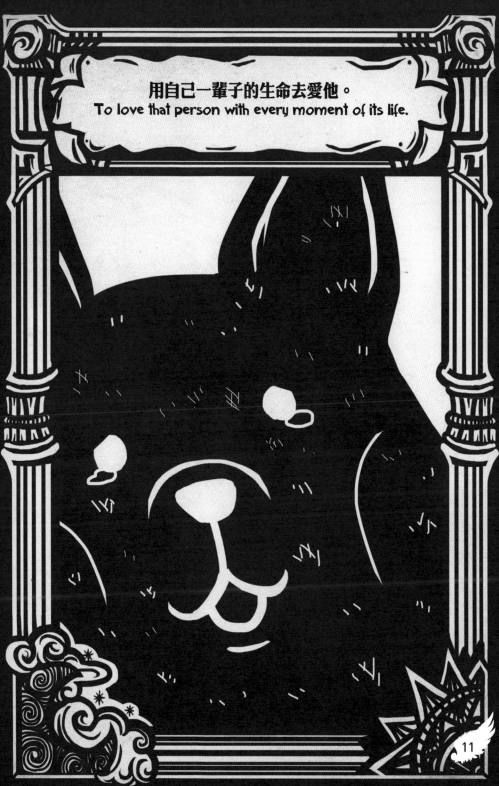

無論貧窮或疾病甚至死亡，
Regardless of poorness, illness or death.

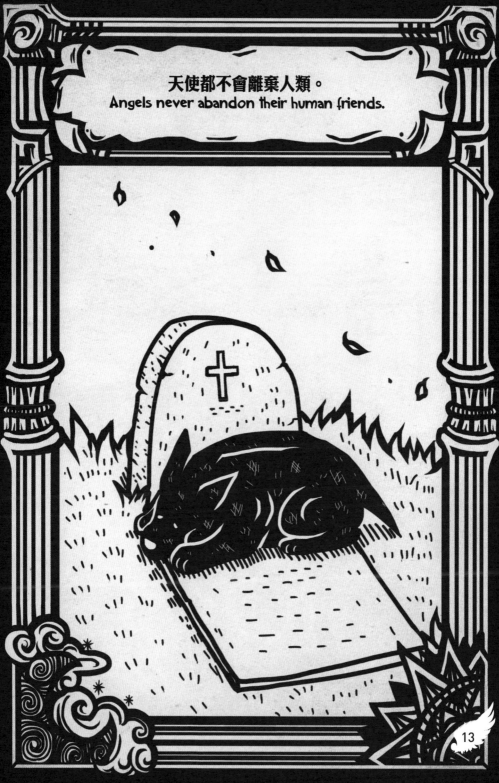

天使的任務就結束了。
Their missions will be completed.

15

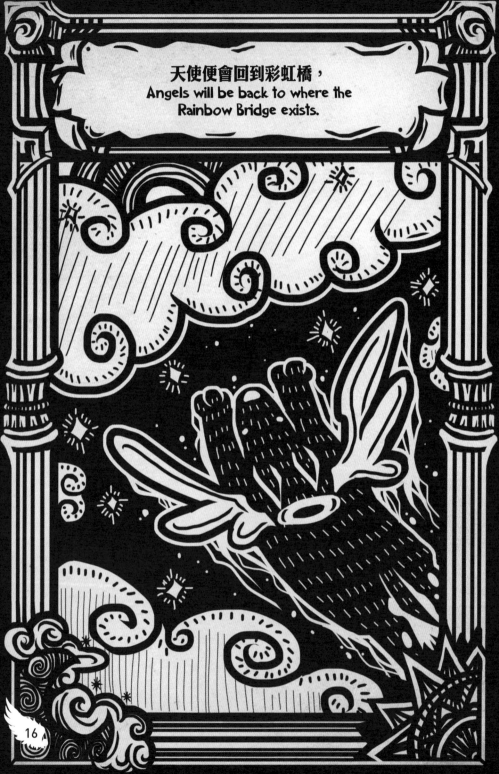

天使便會回到彩虹橋，
Angels will be back to where the
Rainbow Bridge exists.

16

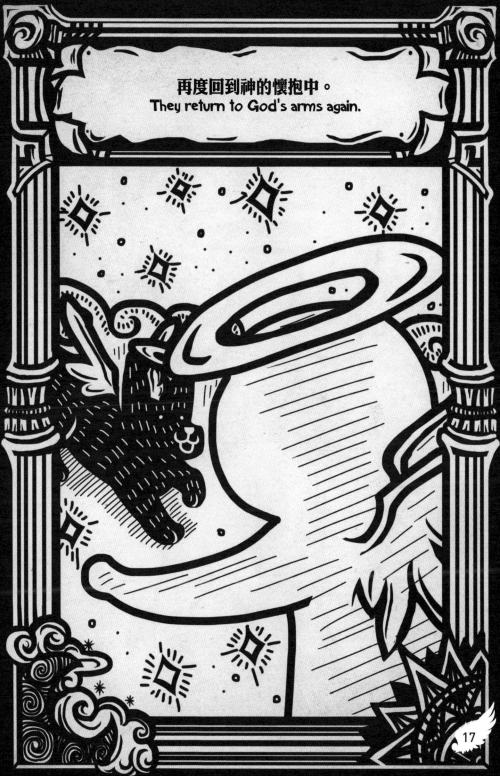

再度回到神的懷抱中。
They return to God's arms again.

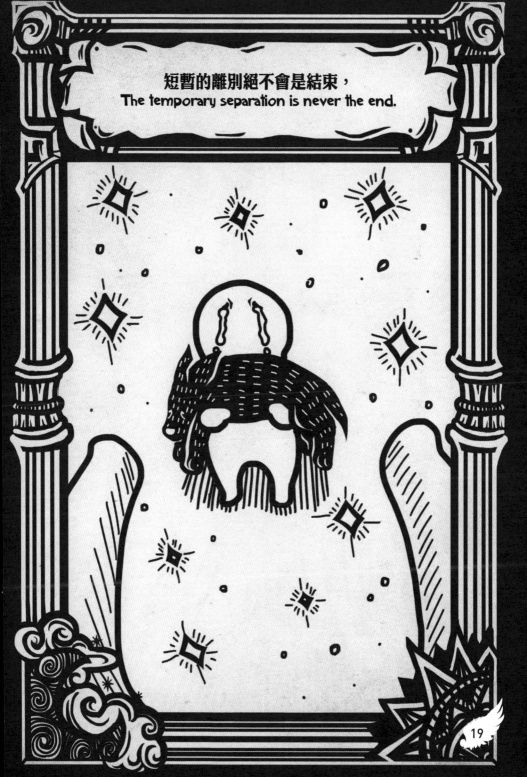

短暫的離別絕不會是結束，
The temporary separation is never the end.

第二章
幼年

Chapter 2
Childhood

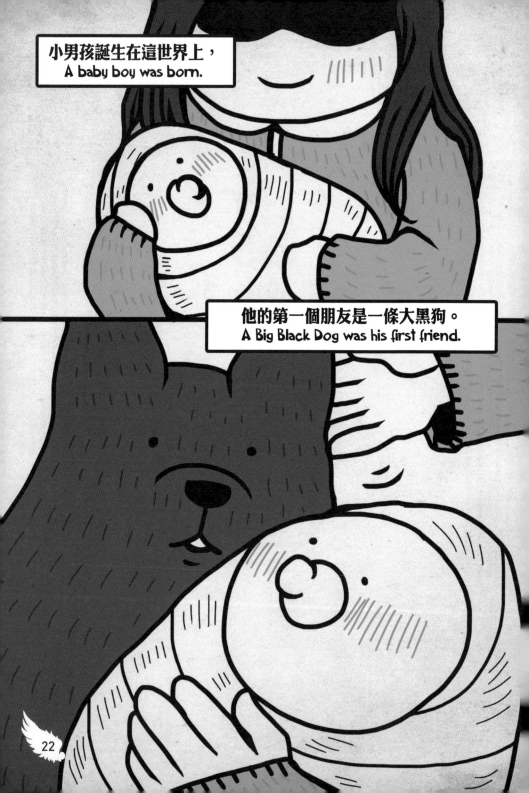

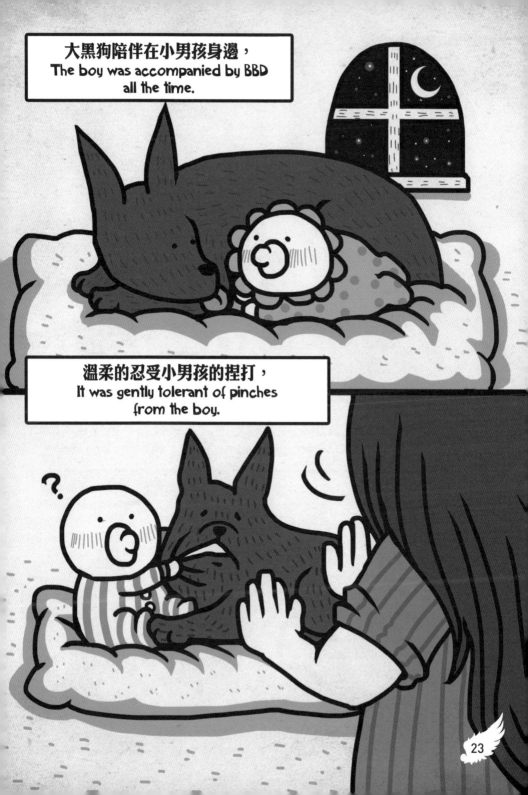

大黑狗陪伴在小男孩身邊，
The boy was accompanied by BBD all the time.

溫柔的忍受小男孩的捏打，
It was gently tolerant of pinches from the boy.

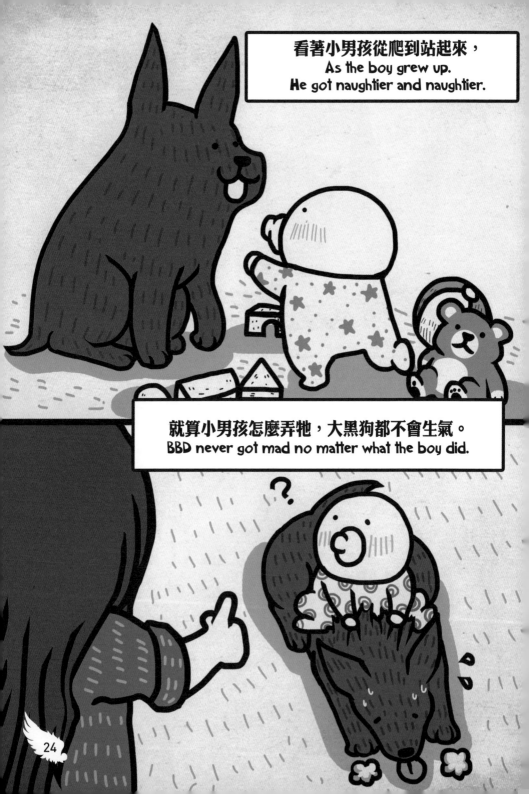

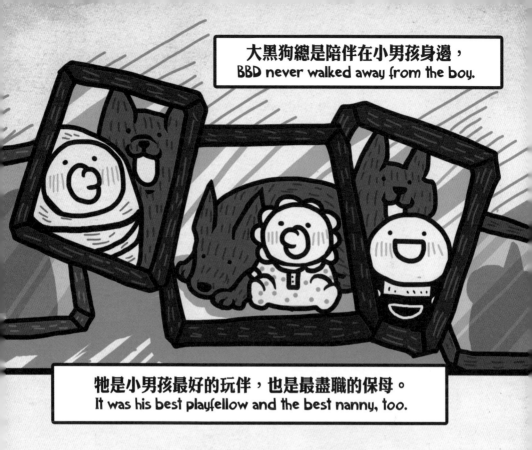

大黑狗總是陪伴在小男孩身邊，
BBD never walked away from the boy.

牠是小男孩最好的玩伴，也是最盡職的保母。
It was his best playfellow and the best nanny, too.

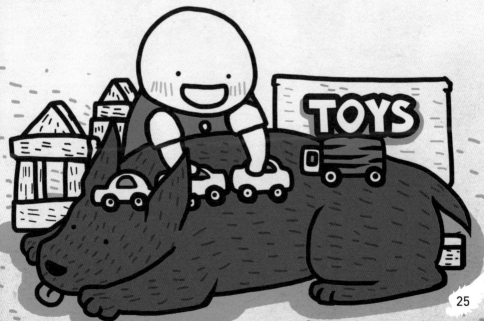

TOYS

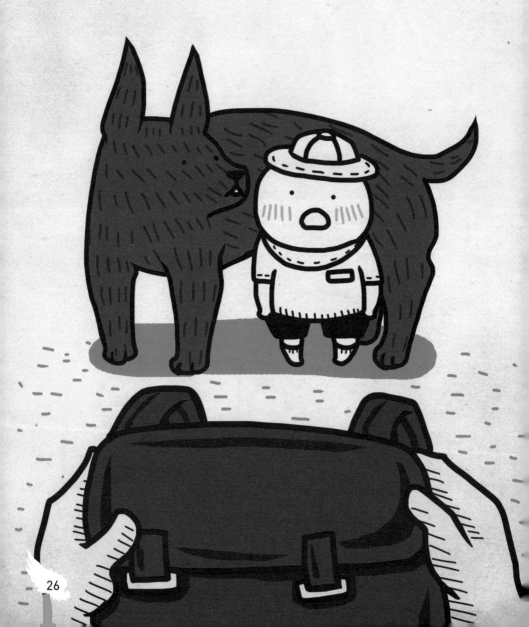

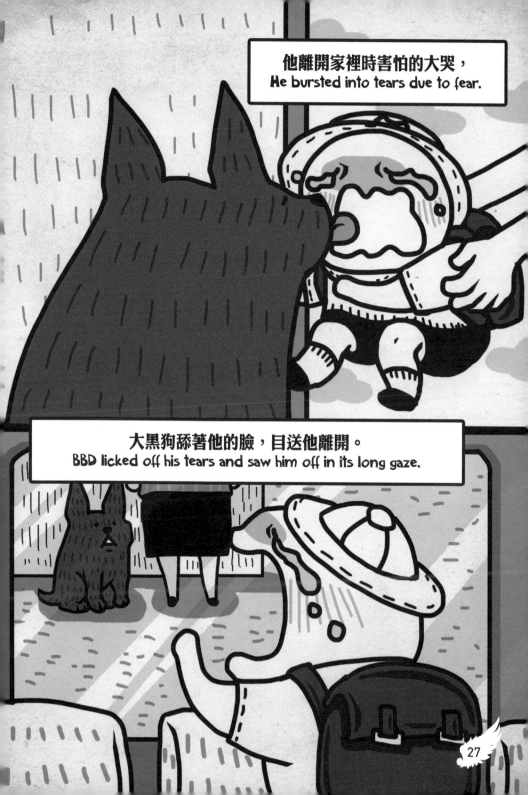

他離開家裡時害怕的大哭，
He bursted into tears due to fear.

大黑狗舔著他的臉，目送他離開。
BBD licked off his tears and saw him off in its long gaze.

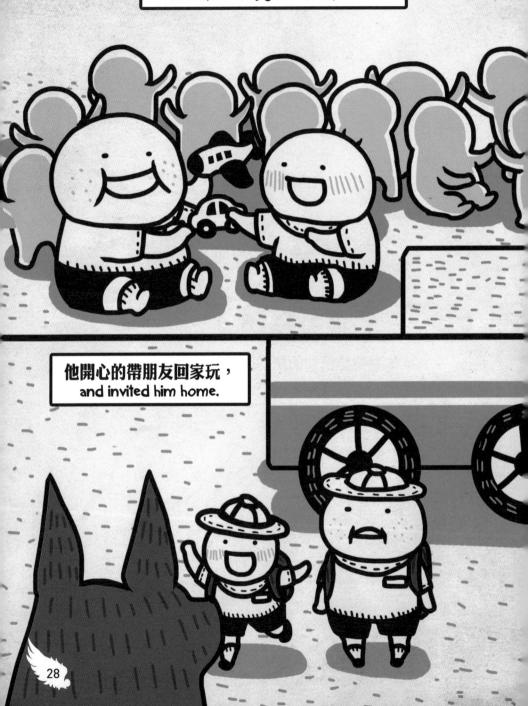

很快的，小男孩交到了新朋友，
Soon, the boy got a new friend

他開心的帶朋友回家玩，
and invited him home.

他們的感情非常好，每晚都一同枕著星空入眠。
They loved each other, they slept together every night.

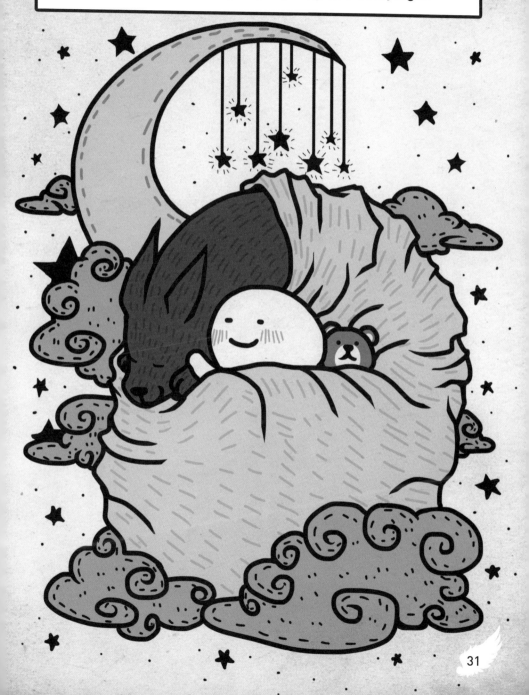

31

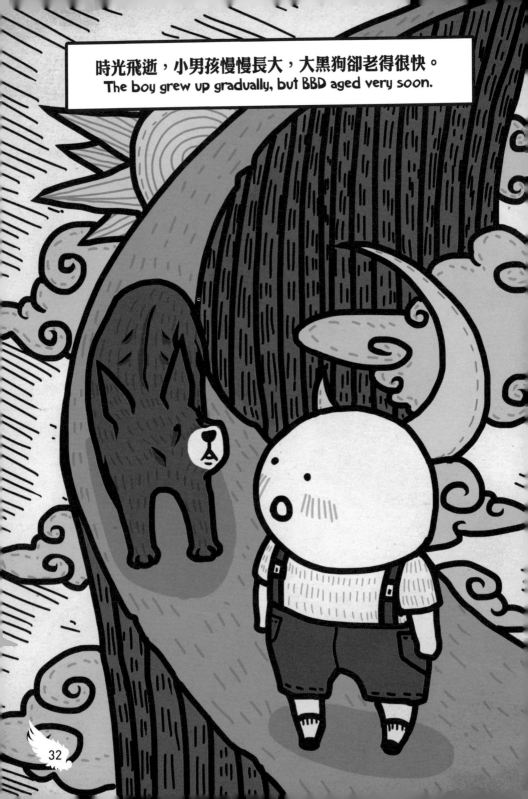

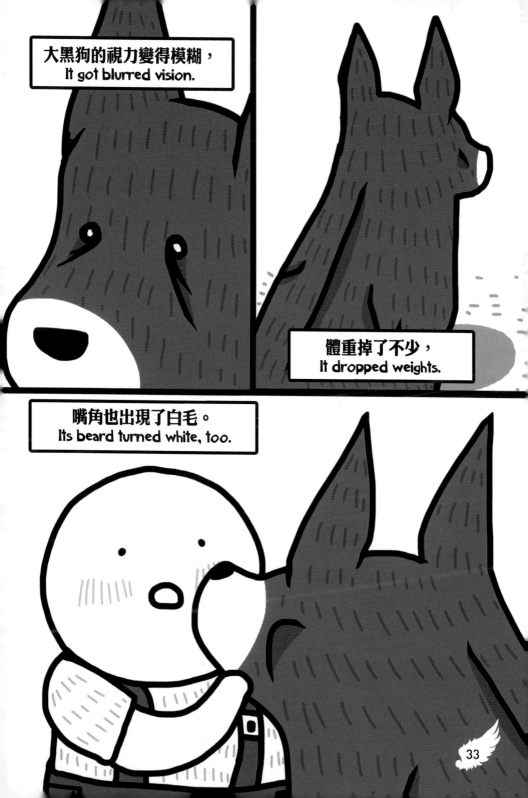

大黑狗的視力變得模糊，
It got blurred vision.

體重掉了不少，
It dropped weights.

嘴角也出現了白毛。
Its beard turned white, too.

33

小男孩發現了變化，
The boy saw the changes.

在玩耍時大黑狗總是呼呼的喘著氣，
BBD carried heavy breaths while playing with him.

步伐變得很緩慢走不太動了，就連追球都顯得很吃力，
It walked slowly, it could barely chase the ball.

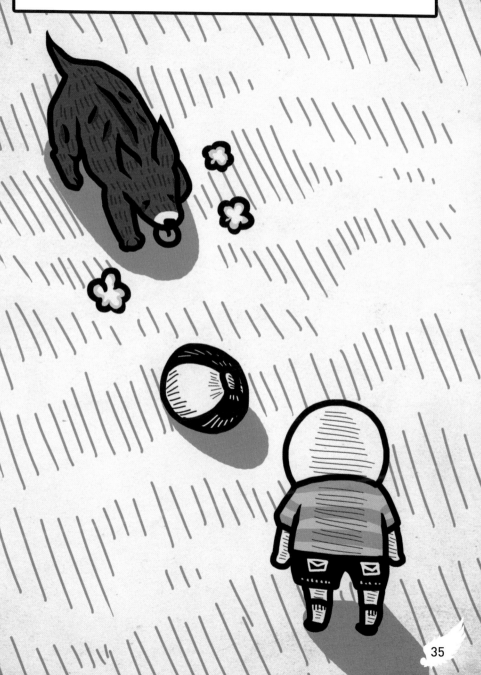

再也不能像以前那樣和他一起奔跑了。
BBD couldn't run around with him anymore.

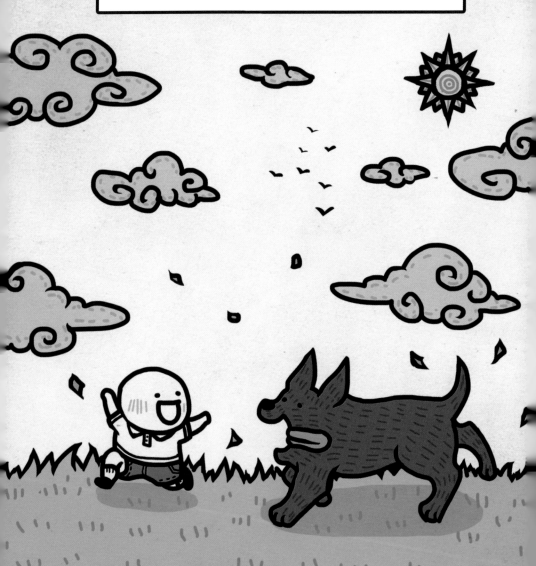

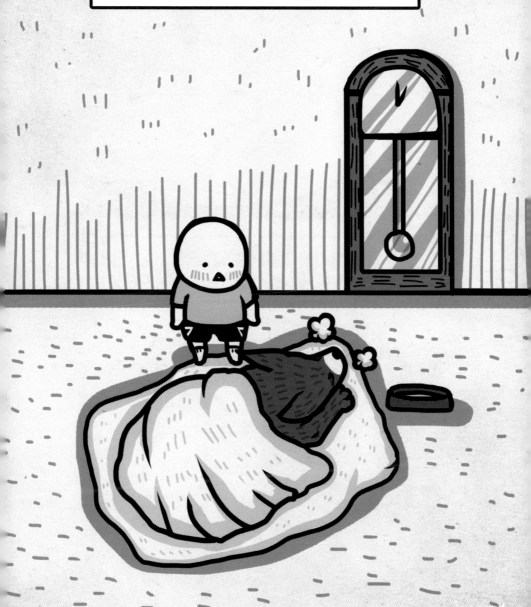

小男孩還太小，他不懂變老是怎麼回事，
The boy was too young,
he had no idea about the aging thing.

37

但他知道大黑狗可能不舒服。
But he knew BBD might not feel good.

他努力的照顧他最好的朋友。
He looked after BBD with his best efforts.

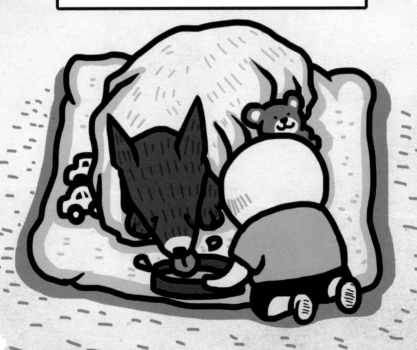

某個早晨，小男孩準備去幼稚園了，
One morning, the boy was ready for school.

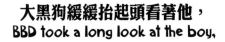

大黑狗緩緩抬起頭看著他，
BBD took a long look at the boy,

小男孩告訴他一定會早點回家。
he told BBD that he would be home A.S.A.P.

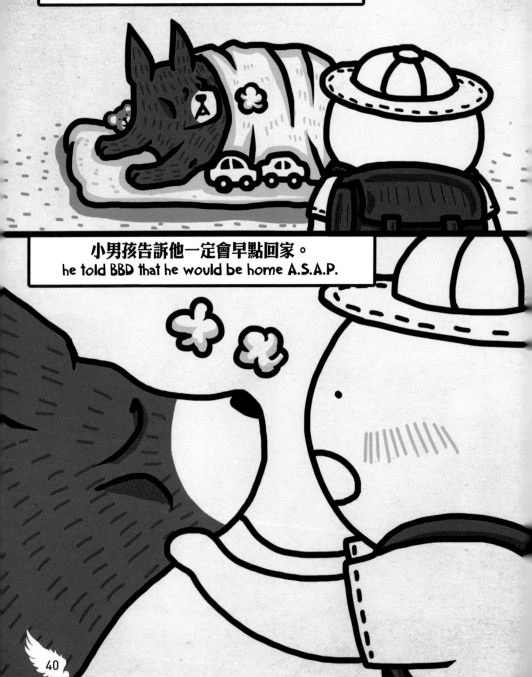

大黑狗的身邊放滿小男孩最喜歡的玩具，
那是小男孩拿出來陪伴牠的。
There were the boy's favorite toys around BBD.

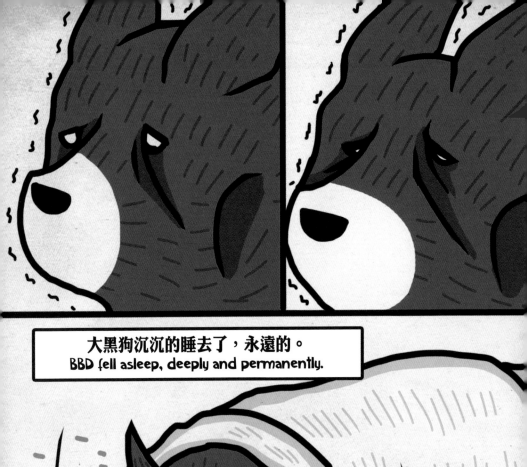

大黑狗沉沉的睡去了，永遠的。
BBD fell asleep, deeply and permanently.

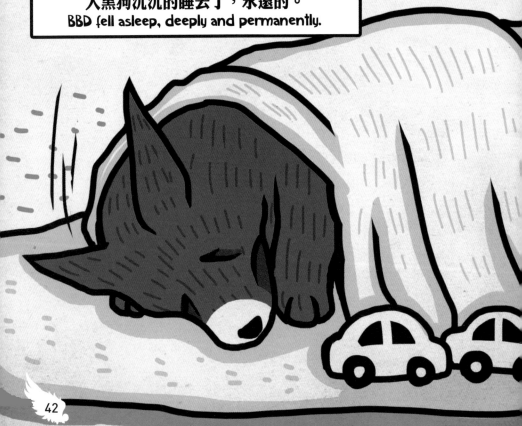

小男孩心裡一直覺得不安，但他不明白是怎麼回事，
The boy was uneasy at school,
but he didn't realize what had happened.

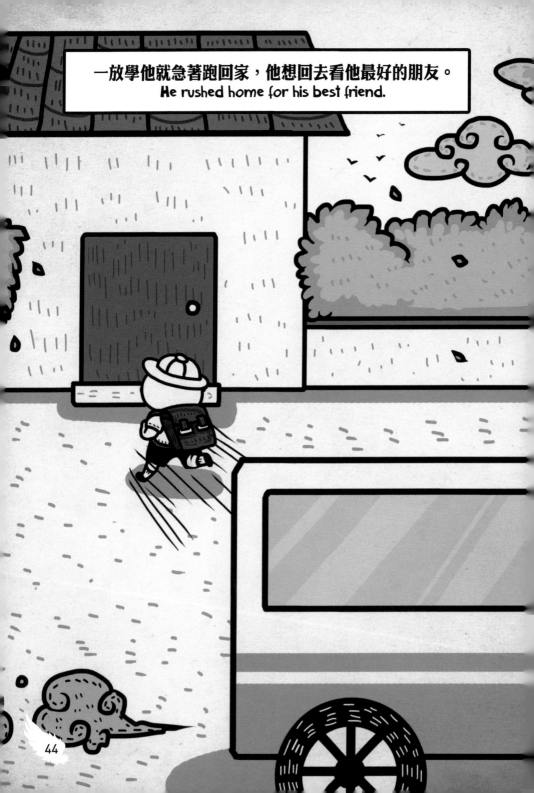

一放學他就急著跑回家，他想回去看他最好的朋友。
He rushed home for his best friend.

44

小男孩滿頭大汗，氣喘吁吁的打開了門。
He opened the door with short breaths and heavy sweats.

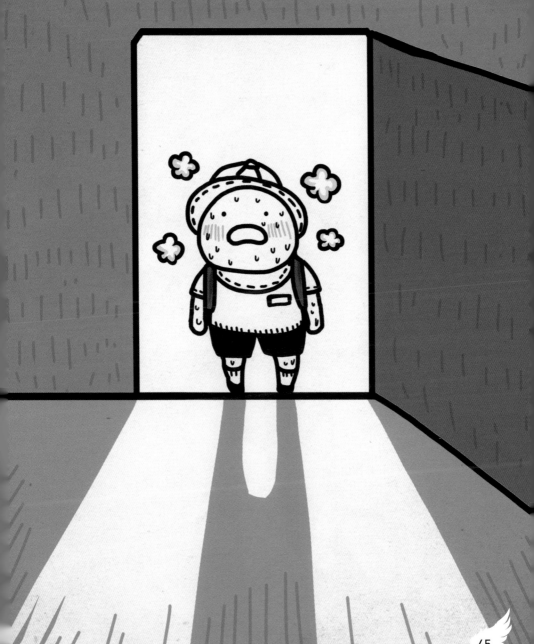

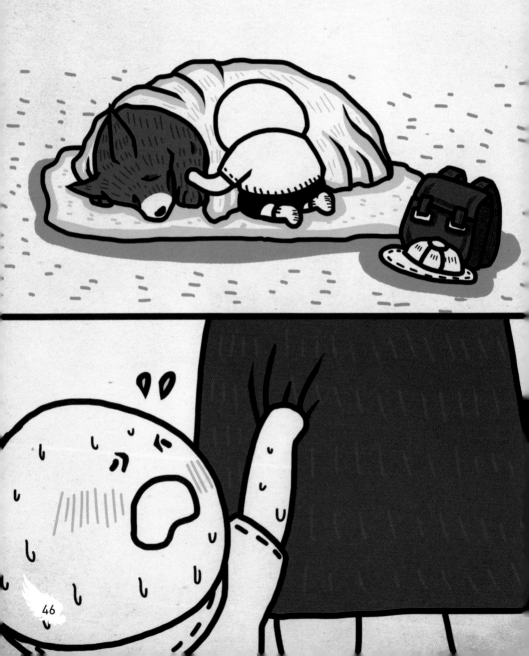

大黑狗在睡覺，儘管裹著毛毯，但身體卻是冰冷的。
BBD seemed to sleep, but its body was ice-cold.

46

媽媽告訴他狗永遠睡著了，
去了很遠的地方不會醒來了。
"BBD has fallen asleep forever.
It has gone to somewhere far away
and won't get up again." mom said.

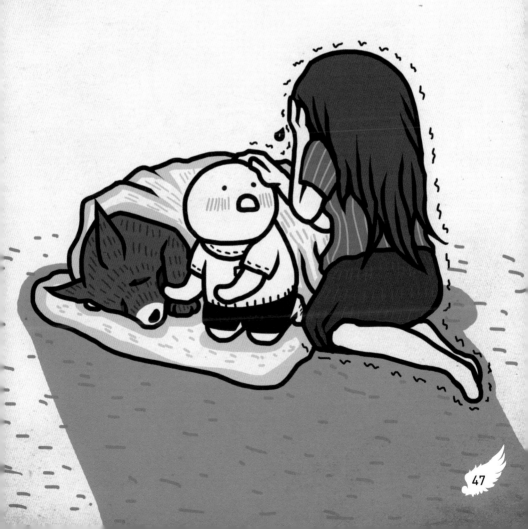

小男孩不能理解這種悲傷，他還不知道死亡是怎麼回事。
The boy couldn't comprehend such a sorrow,
he had no idea about death yet.

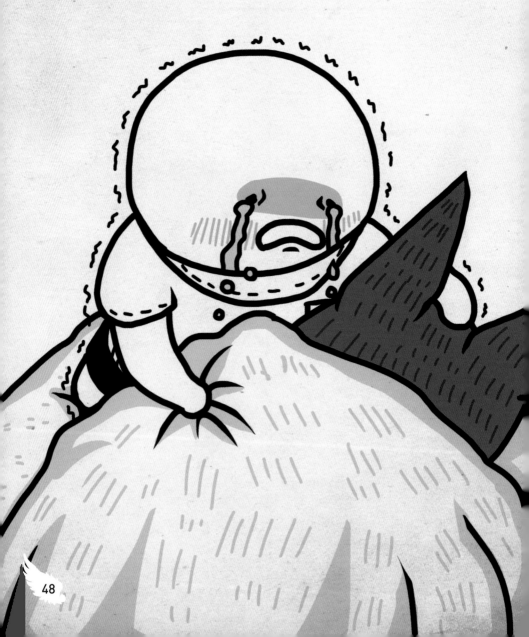

但他知道一直陪伴自己的狗已經不在了，
狗離開他去了很遠的地方不會再回來了。
But he knew his dog has gone
and it will not come back anymore.

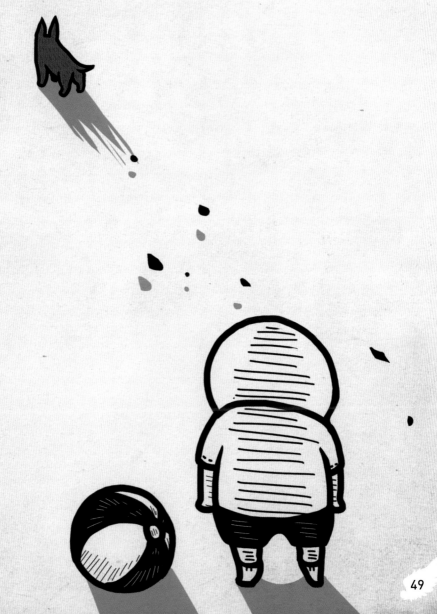

49

寵物樂園的人來了，他們要帶走大黑狗，
The undertakers came.
They were here to take BBD away.

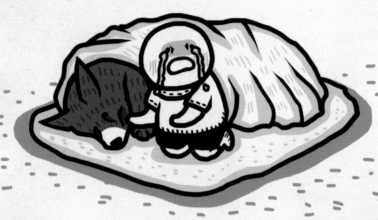

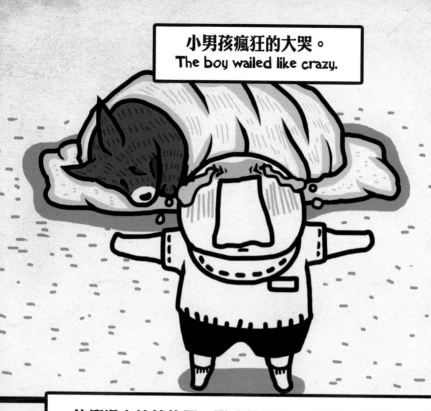

小男孩瘋狂的大哭。
The boy wailed like crazy.

他衝過去拉著他們，阻止他們帶走他最好的朋友。
He dragged their clothes and tried to stop them.

媽媽把他拉開，小男孩看著大黑狗被人帶走了，
Mommy stopped him. They just took BBD away.

他非常非常的難過，心好像被戳破了一個洞。
Overwhelming sadness took the boy,
his heart was almost broken.

小男孩哭著哭著，終於累到睡著了，淚水浸溼了他的枕頭。
He was exhausted as too many tears.
He fell asleep with a wet pillow.

睡夢中，一朵朵的白雲籠罩了他的夢境。
There were plenty of clouds in his dream.

他站在一片大草原上，大黑狗跟他一起玩耍。
He stood on a prairie and there was BBD playing with him.

在夢裡，狗看起來很年輕、很健康、很有精神。
BBD looked so young, so healthy and so energetic.

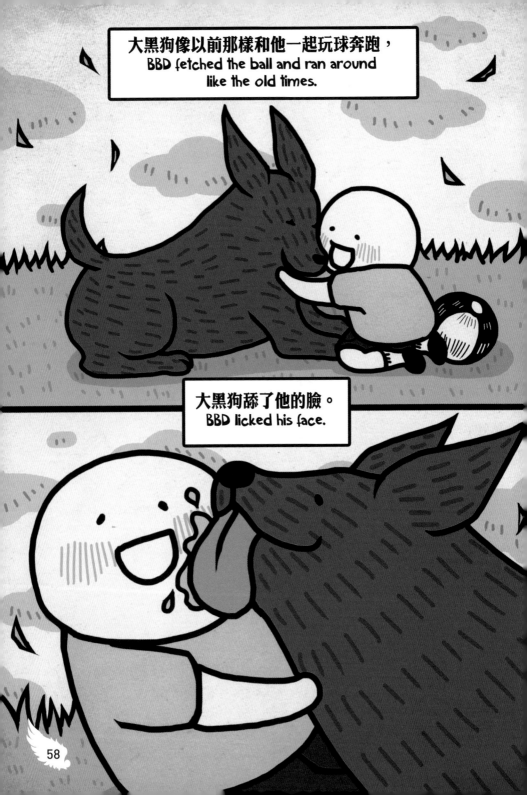

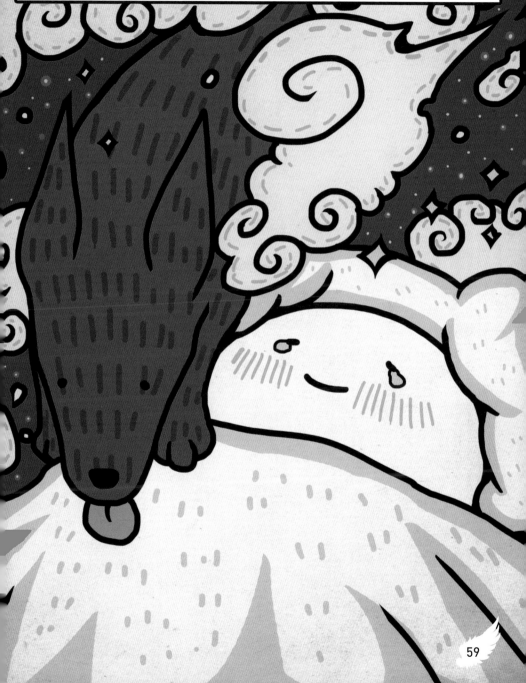

睡夢中，小男孩終於不再哭泣，他知道，大黑狗回來安慰他了。
The boy stopped crying in his dream,
he knew BBD was always there for him.

第三章
少年

Chapter 3
Teenage

時光匆匆流逝，小男孩換上了制服，他已經是個小學生了。
Time went fast, the boy became an elementary student.

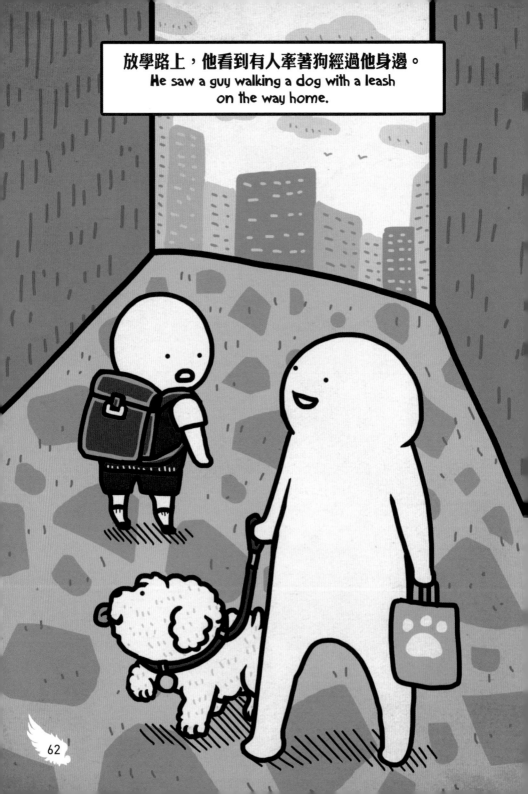

放學路上，他看到有人牽著狗經過他身邊。
He saw a guy walking a dog with a leash on the way home.

62

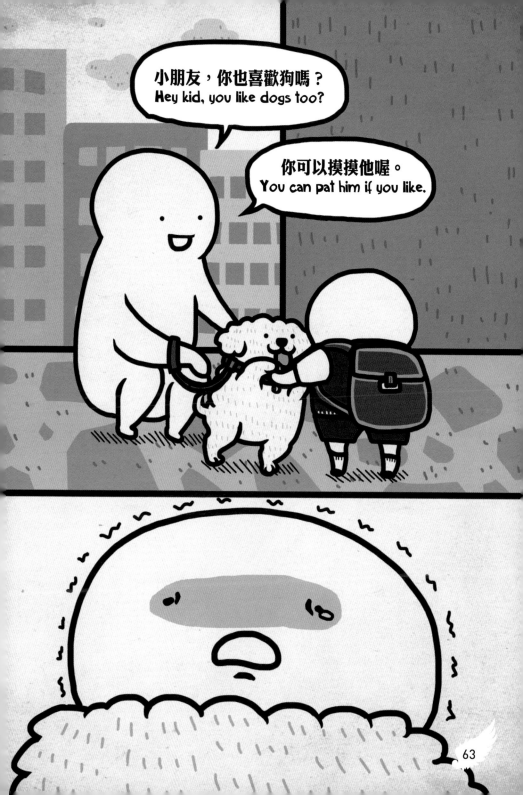

小男孩一路跑回家，他想起了他已經離開了的，最好的朋友。
They reminded him of his best friend, the one that's long gone.

房間的角落，大黑狗的墊子和水碗一直都沒有收起來，
BBD's bed and water bowl were still at the corner of his room.

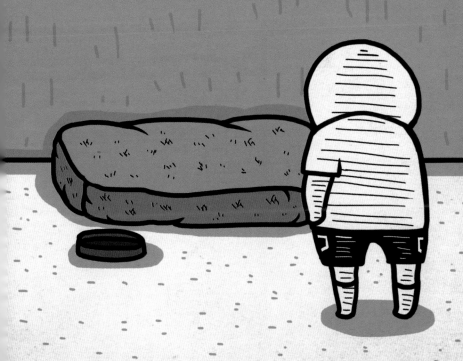

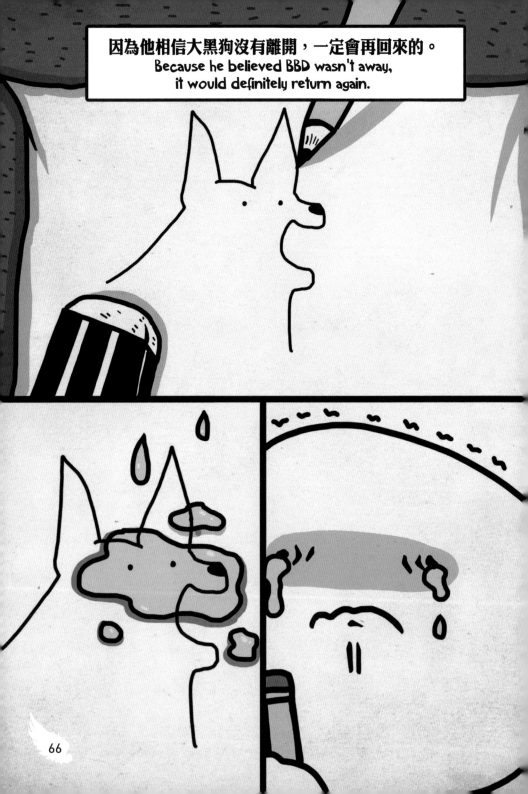

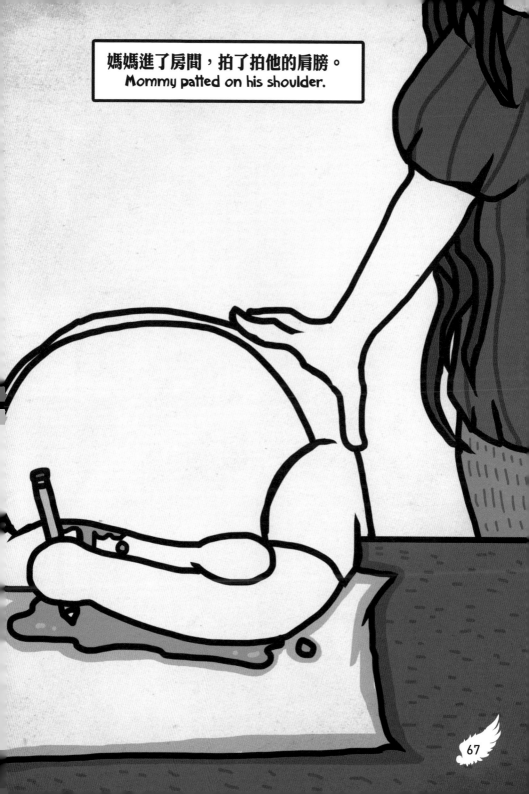

媽媽進了房間，拍了拍他的肩膀。
Mommy patted on his shoulder.

媽媽抱了一隻小黃狗給他，那是她特地去領養回來陪他的。
There was a yellow poppy in mommy's arms! She adopted just for him!

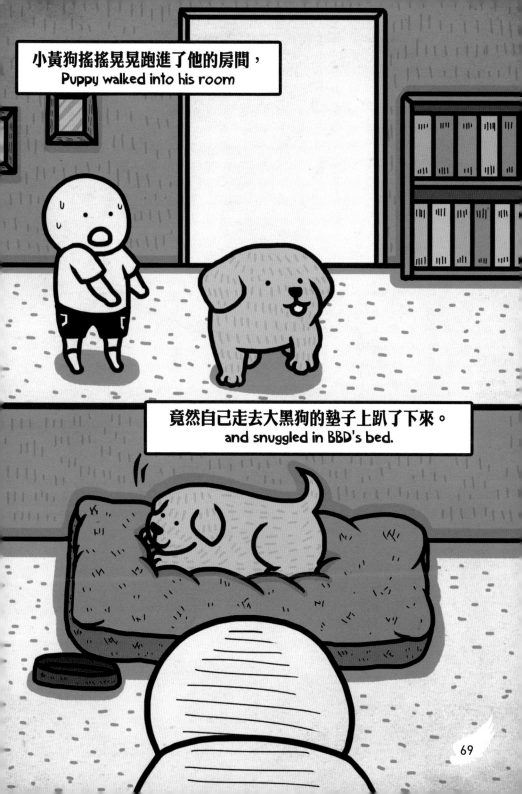

小黃狗搖搖晃晃跑進了他的房間，
Puppy walked into his room

竟然自己走去大黑狗的墊子上趴了下來。
and snuggled in BBD's bed.

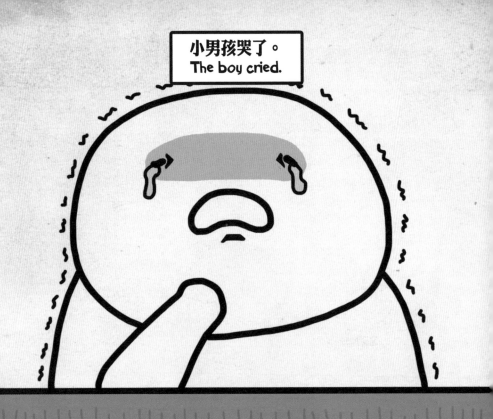

小男孩哭了。
The boy cried.

他抱著小黃狗，他相信是大黑狗帶了這個新朋友來陪伴他。
He believed BBD brought this new friend to him.

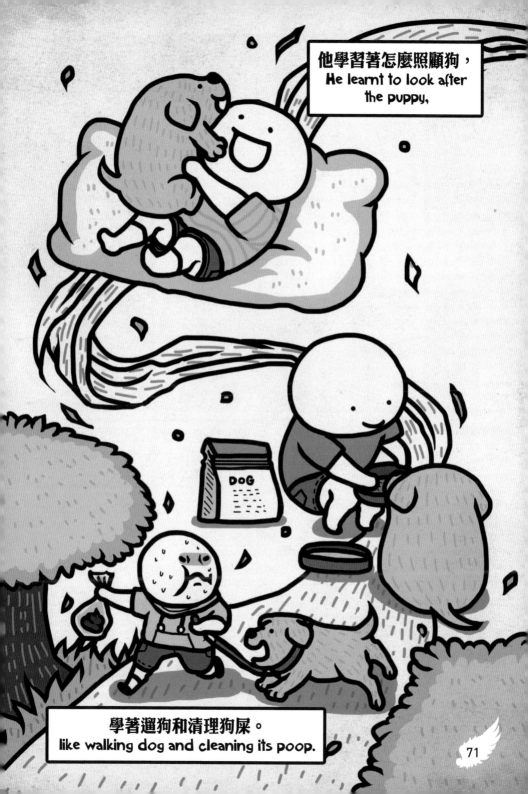

他學習著怎麼照顧狗，
He learnt to look after the puppy,

學著遛狗和清理狗屎。
like walking dog and cleaning its poop.

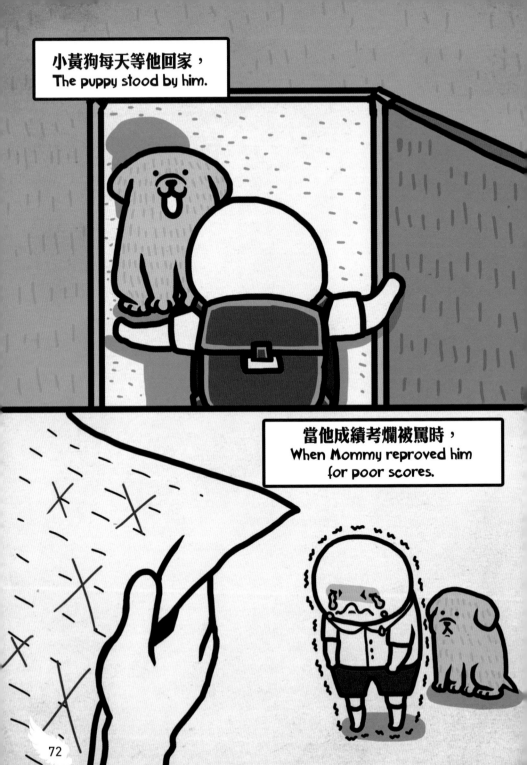

小黃狗都會和大黑狗一樣靜靜的
陪伴在他身旁，像是在安慰他。
The puppy accompanied him
and appeased him like BBD did.

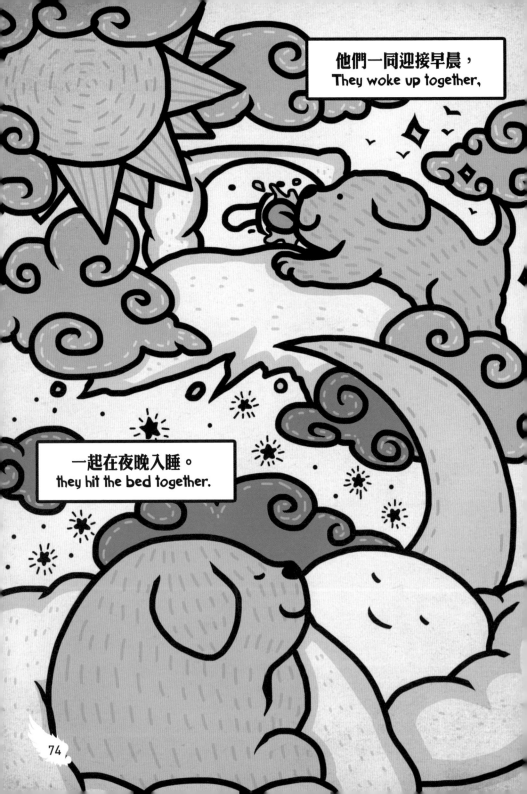

小黃狗長得很快，變成了一隻大黃狗。
The puppy grew into a Big Yellow Dog.

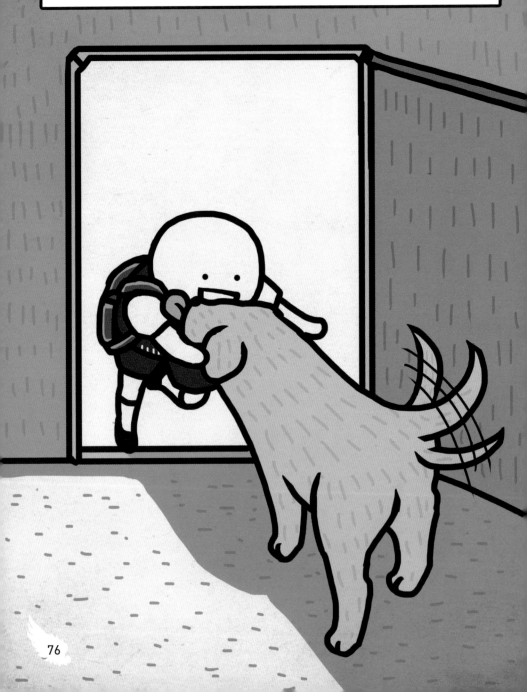

大黃狗每天等著小男孩放學，在門口熱情的迎接他。
BYD passionately welcomed him home every day.

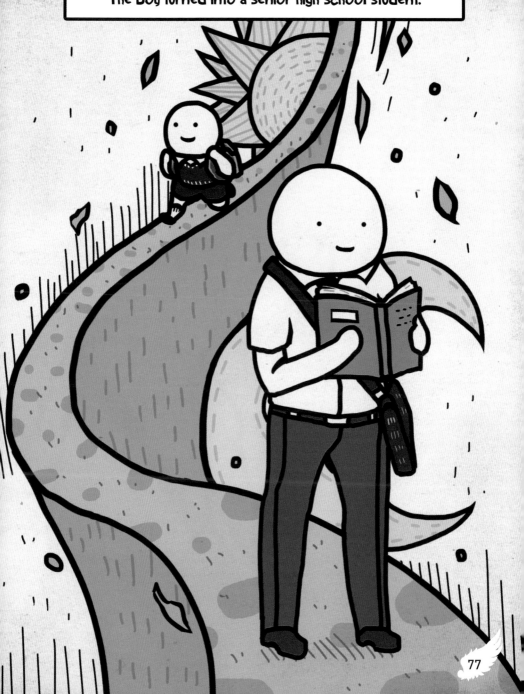

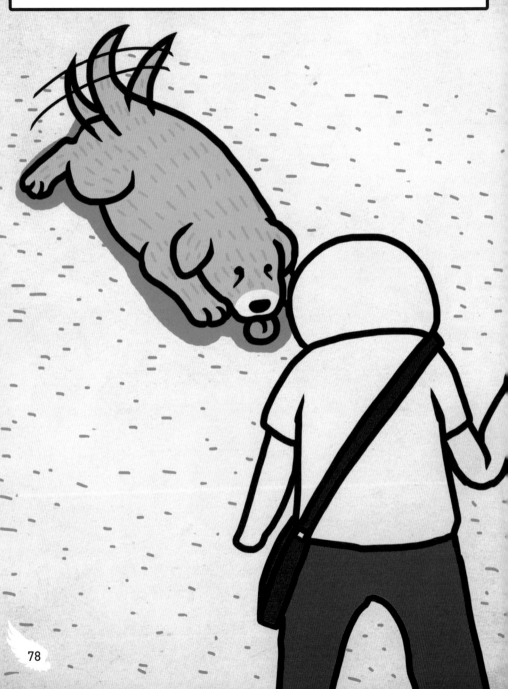

大黃狗依舊每天等著少年回家，但牠趴著睡覺的時間卻越來越多。
BYD still awaited him at home every day. But it was sleepy more.

78

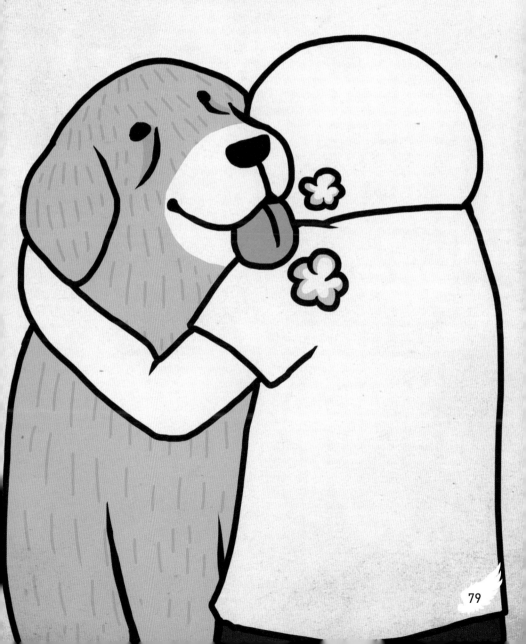

少年知道大黃狗慢慢變老了。
The boy understood that BYD was getting older.

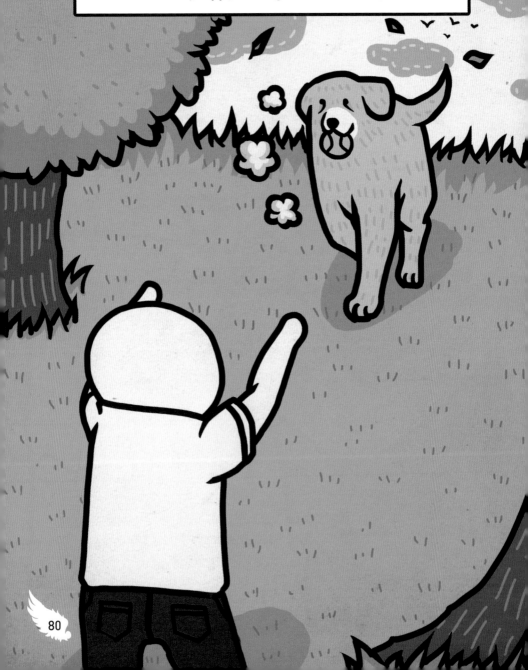

他們依然常常出去玩球，就像以前一樣 。
大黃狗雖然氣喘吁吁的撿球，但還是很開心。
They still did fetching ball often, like the good old times.
BYD was very happy although it was short of breath.

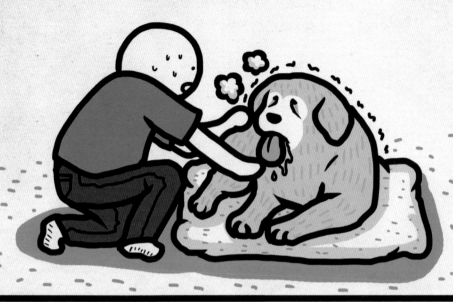

大黃狗老的很快，少年發現狗生病了，
BYD aged very soon. It was sick,

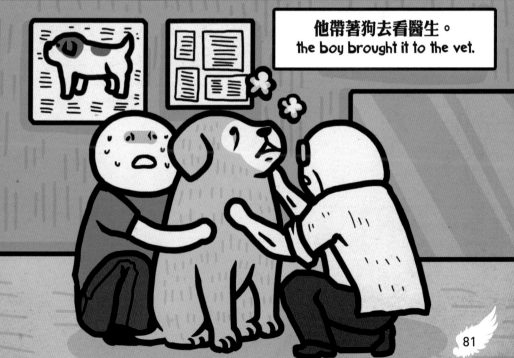

他帶著狗去看醫生。
the boy brought it to the vet.

大黃狗是他的家人、他最好的朋友，他希望大黃狗能快點好起來。
BYD was his family and best friend. He wanted it to recover A.S.A.P.

終於，在他回家時，大黃狗連爬起來迎接他的力氣都沒有了。
At last, BYD lost its last strength. It couldn't run to the boy when he got home.

83

更不要說是像以前一樣和他一起玩球或奔跑了。
Not to mention fetching ball or running.

少年知道大黃狗正在離開他，但卻無能為力。
The boy realized that BYD was on the way to another world.
But he couldn't do anything.

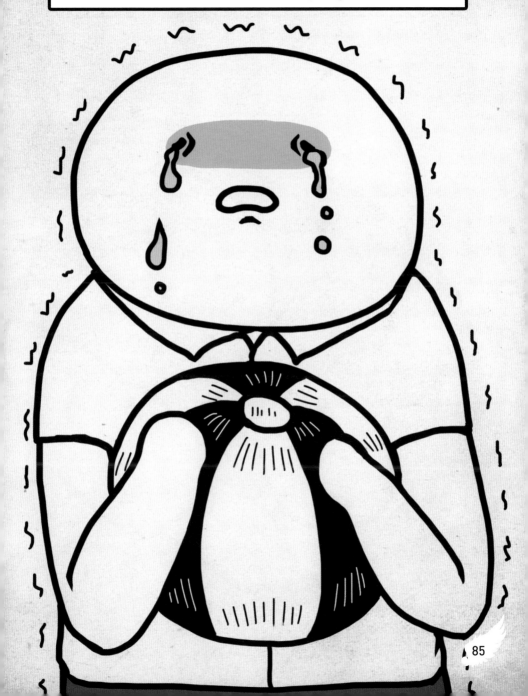

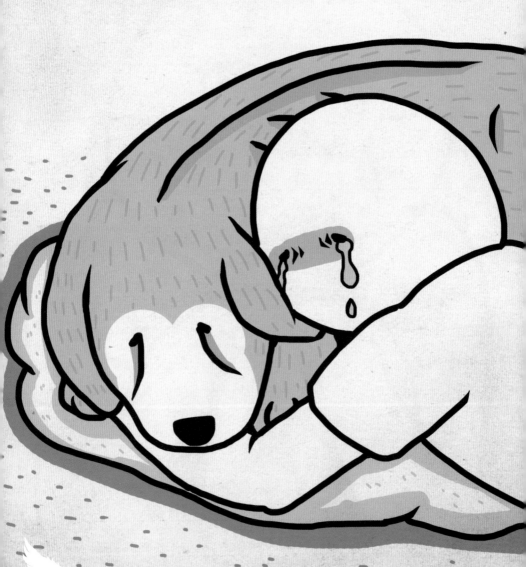

他緊緊抱著大黃狗，希望牠陪他久一點。
He held BYD tightly, he wished BYD could stay longer.

像滾動的球終將會靜止不動，大黃狗的生命也走到了盡頭。
The end of BYD's life was just one-step away.

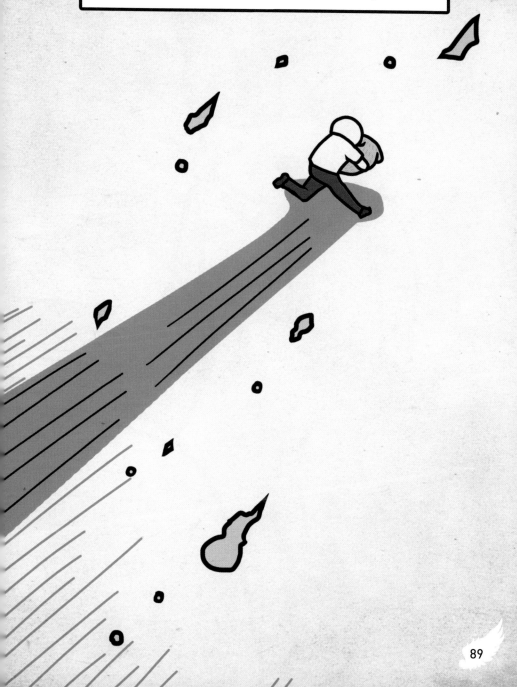

他用盡一切的力量，拔腿狂奔到最近的動物醫院。
He ran to the vet and sought for help.

89

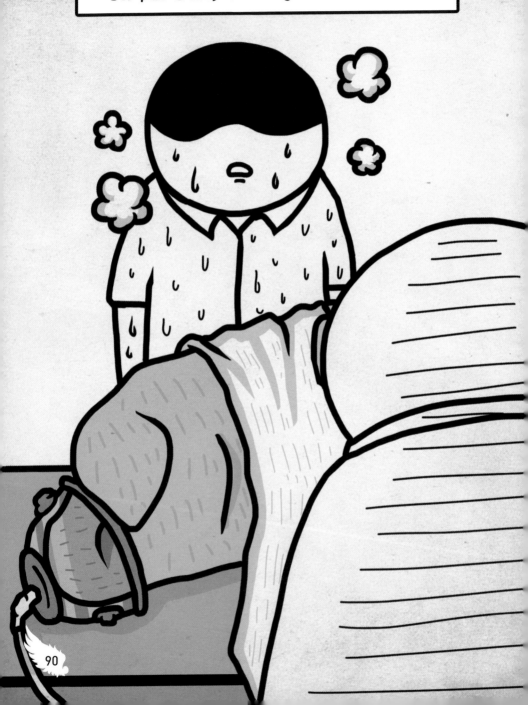

醫生搶救過後，大黃狗還是走了。
BYD passed away even though the vet did his best.

他親手送走了大黃狗，看著大黃狗的身體火化，被火焰吞噬。
The fire swallowed BYD in the cremation ceremony.

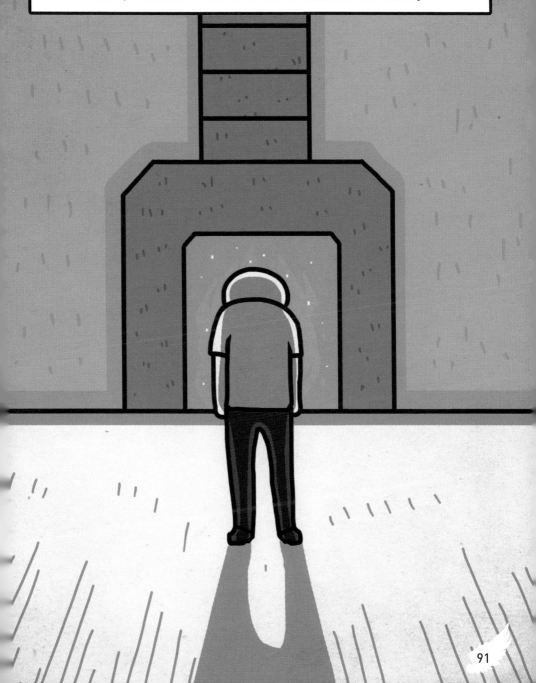

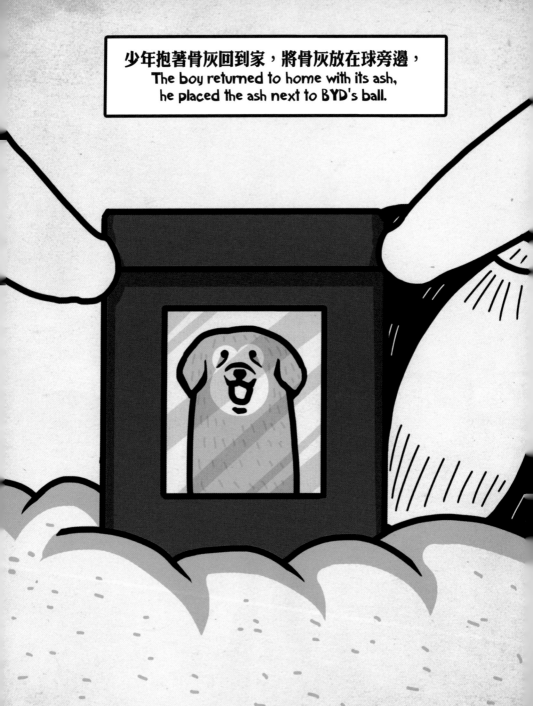

少年抱著骨灰回到家，將骨灰放在球旁邊，
The boy returned to home with its ash,
he placed the ash next to BYD's ball.

他知道，又一個家人離開了他。
He lost a family again.

94

成年的他已經是個上班族了，每天工作過著忙碌的生活。
The fully grown boy became a salaryman, he was busy for work every day.

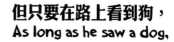

但只要在路上看到狗，
As long as he saw a dog,

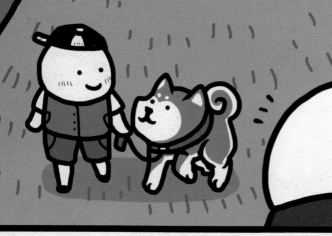

他總會停下腳步多看幾眼，或是摸摸狗的頭。
he would stop and pat the dog.

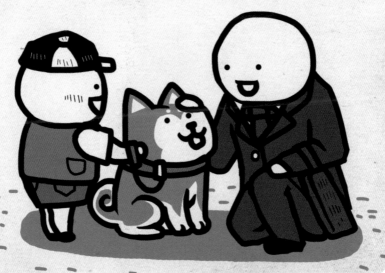

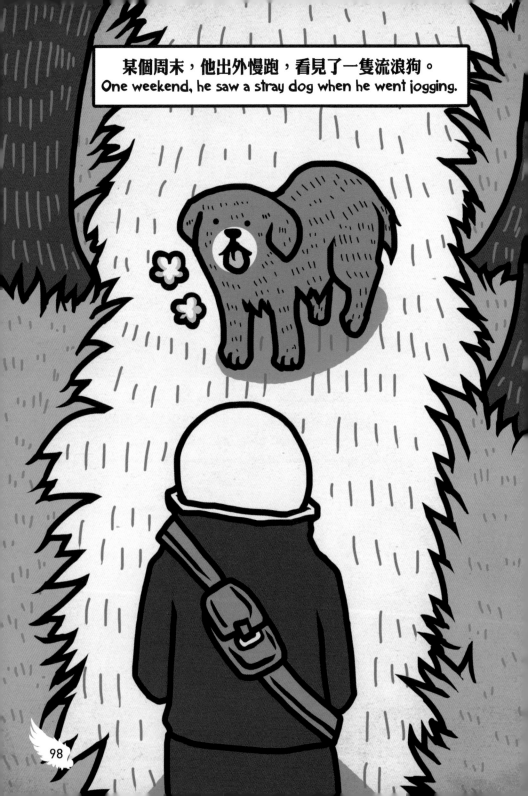

某個周末，他出外慢跑，看見了一隻流浪狗。
One weekend, he saw a stray dog when he went jogging.

他遇到了一個在餵狗的女孩，
He encountered a girl who was feeding dogs.

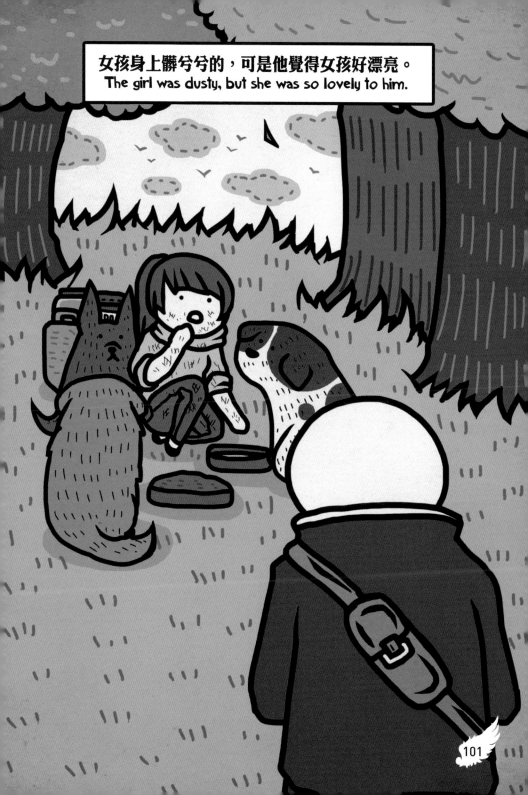

女孩身上髒兮兮的，可是他覺得女孩好漂亮。
The girl was dusty, but she was so lovely to him.

101

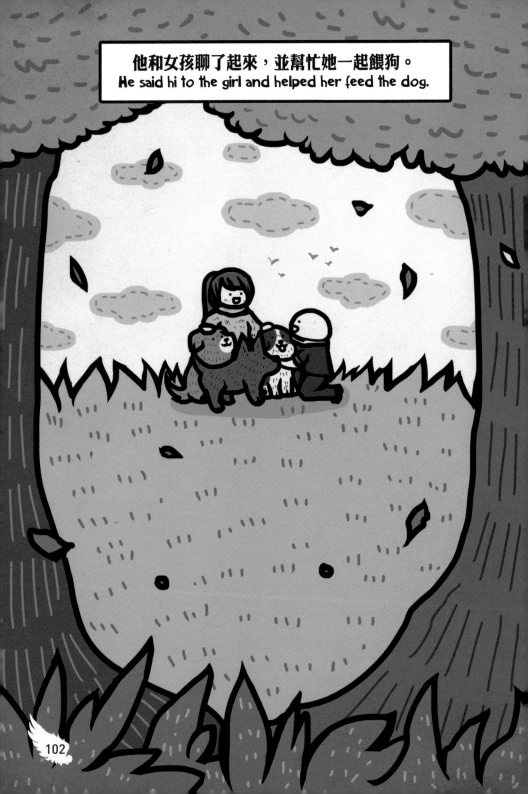

他和女孩聊了起來，並幫忙她一起餵狗。
He said hi to the girl and helped her feed the dog.

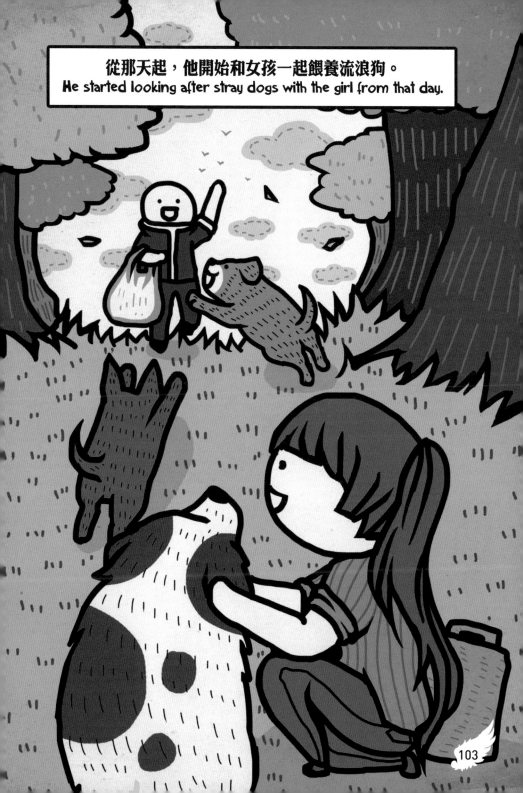

從那天起，他開始和女孩一起餵養流浪狗。
He started looking after stray dogs with the girl from that day.

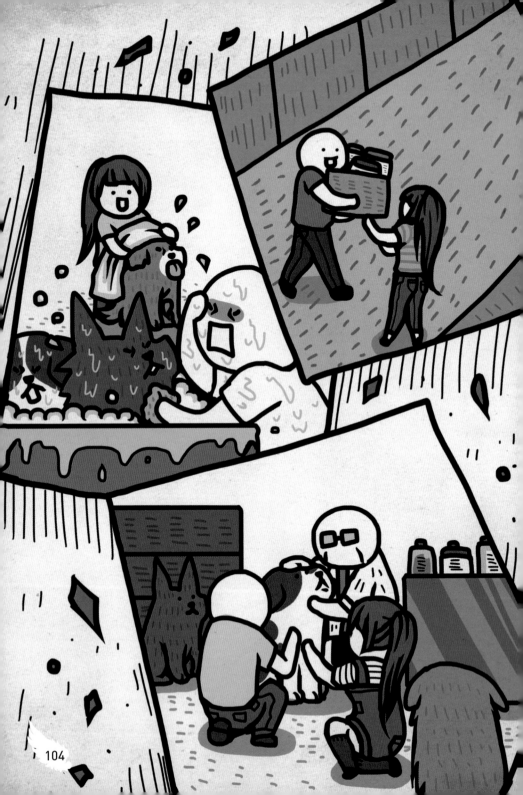

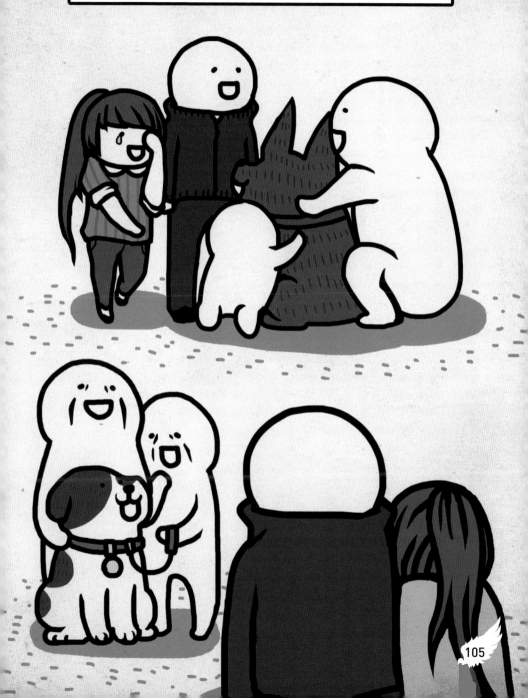

他們也一起幫狗陸續找到了新的主人。
They recruited new owners for dogs, one after another.

這天，他們餵養的最後一隻流浪狗也找到了幸福的家，
This day, they got the last stray dog a happy home.

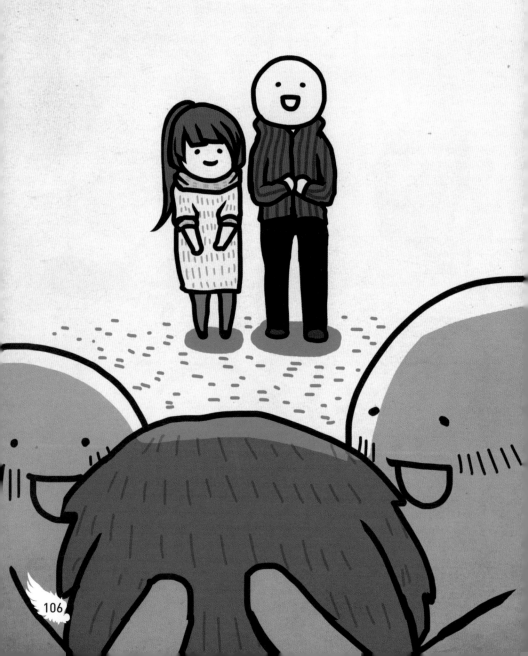

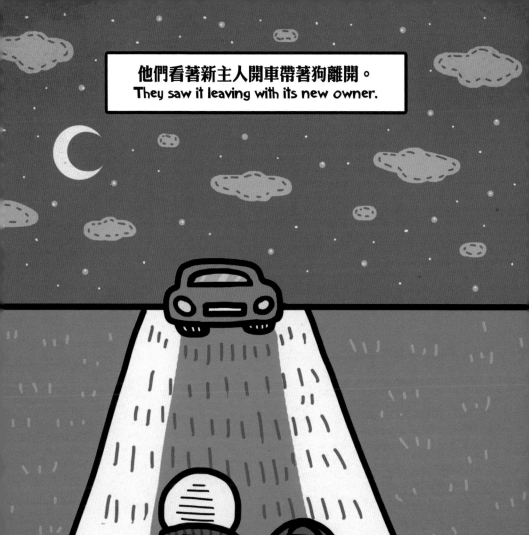

他們看著新主人開車帶著狗離開。
They saw it leaving with its new owner.

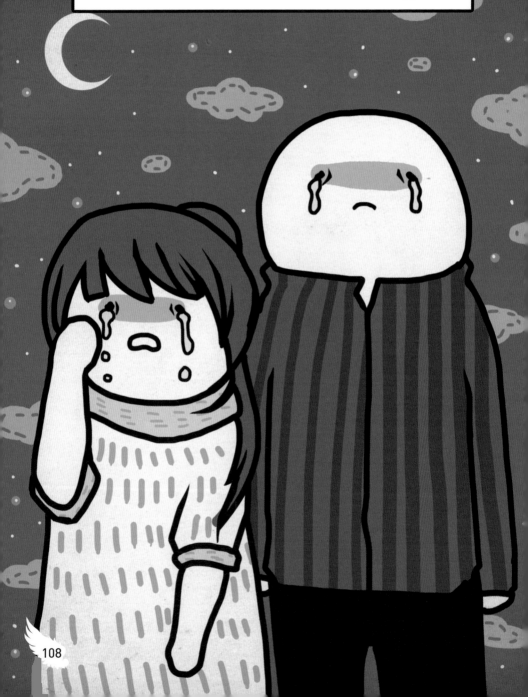

不知道怎麼的，他哭了，女孩也哭了。
There were tears on their cheeks for its future happy life.

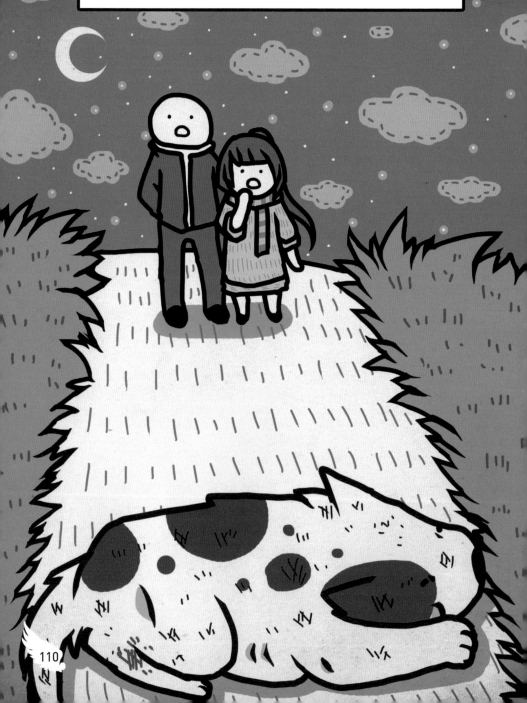

一個晚上，他們在路邊看到一隻腿受傷的大花狗。
They saw a Big Spotty Dog with an injured leg.

110

大花狗似乎被人類打過，非常的怕人。
BSD was deeply afraid of human, it seemed to be abused.

111

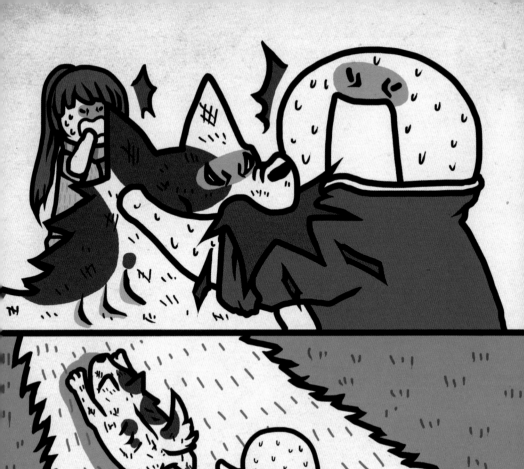

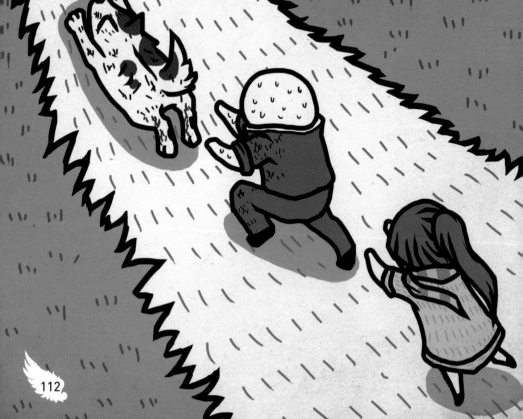

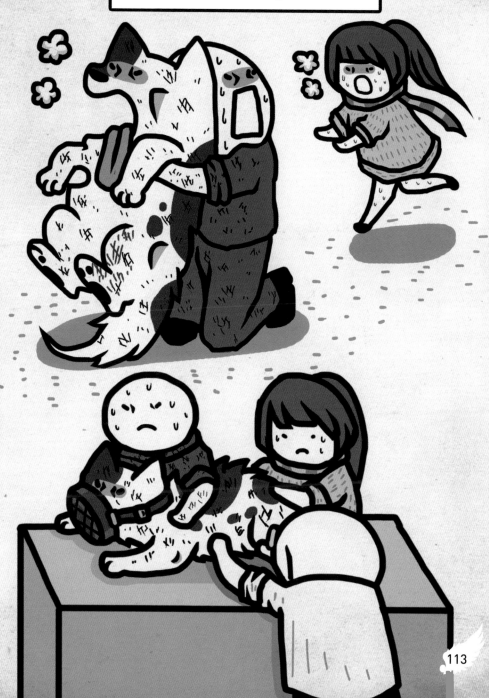

他和女孩硬是拖著狗去看了醫生。
They tried hard to bring it to the vet.

雖然這隻狗很兇，並不親人，但他們兩人還是一起照顧大花狗。
BSD was **NOT** friendly at all, but they took really good care of it.

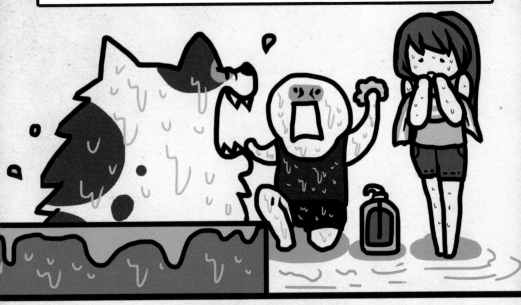

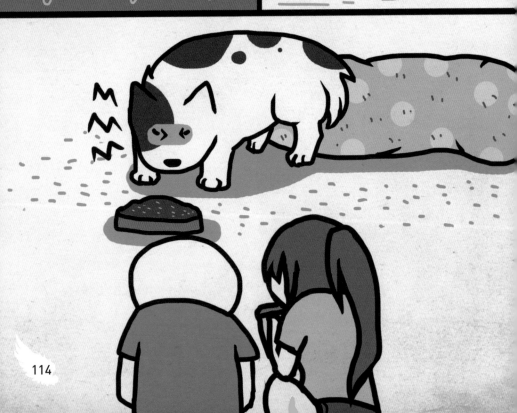

漸漸的，大花狗彷彿知道他們是真心對他好。
BSD was aware of their true kindness.

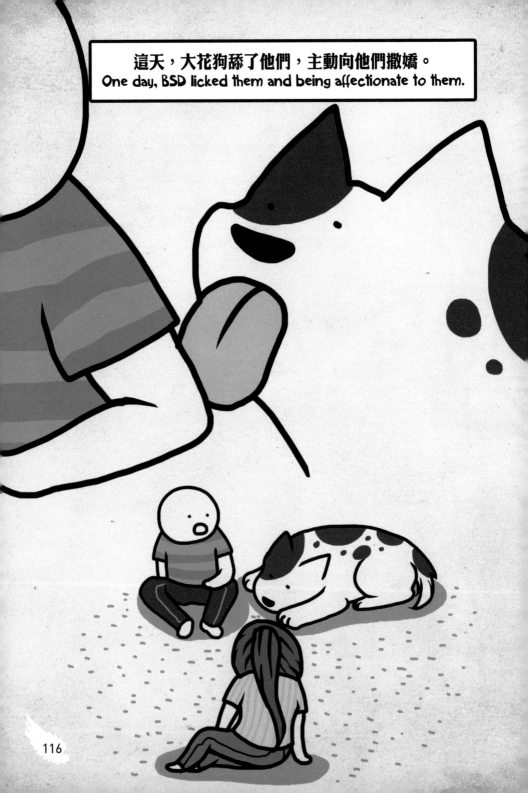

這天，大花狗舔了他們，主動向他們撒嬌。
One day, BSD licked them and being affectionate to them.

116

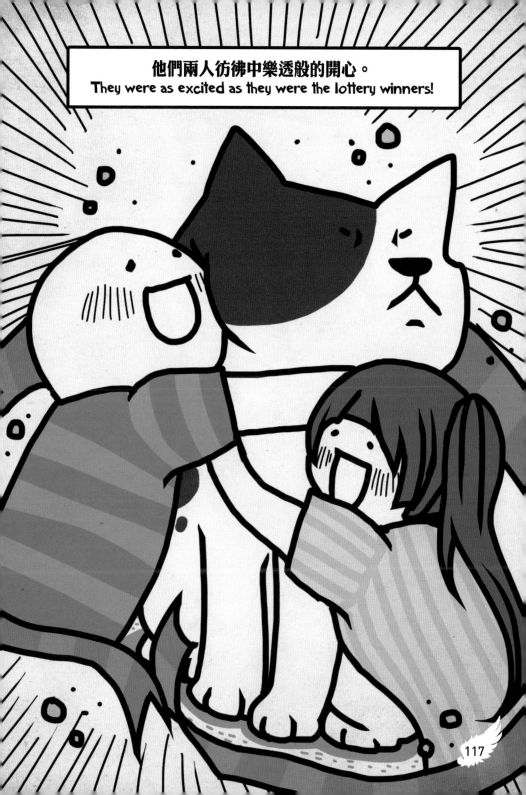

117

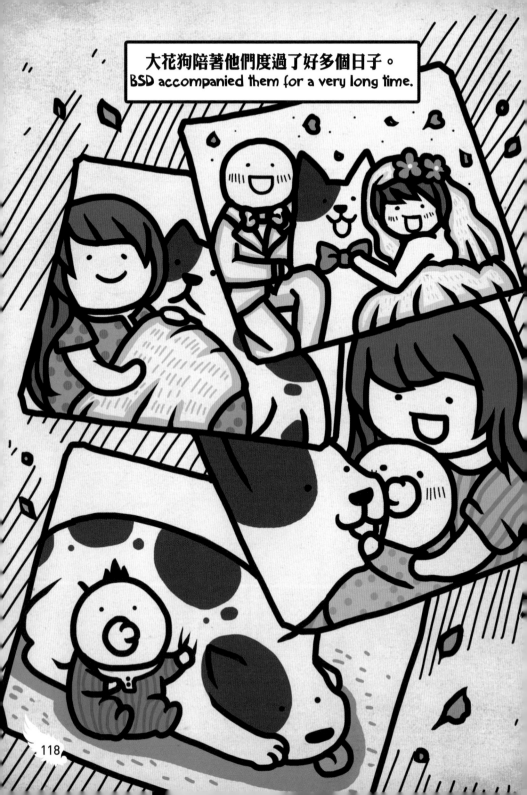

他下班了，老婆、兒子、大花狗一起迎接他回家。
He was welcomed by his wife, son and BSD when he got home.

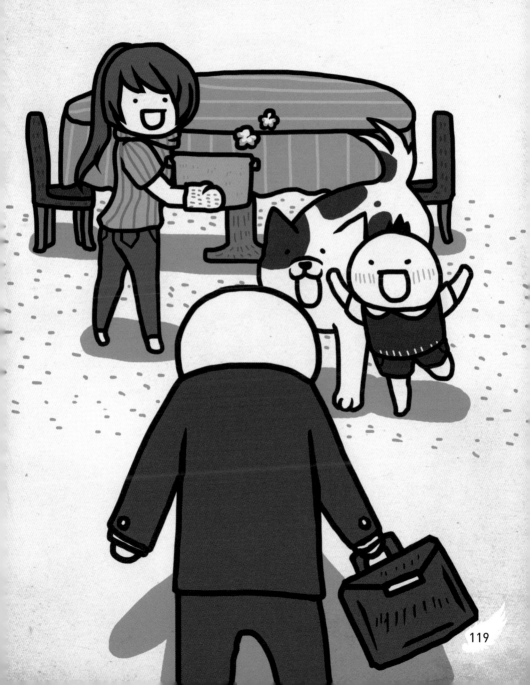

119

他很幸福，這是他人生最快樂的時光。
That was the happiest time in his life.

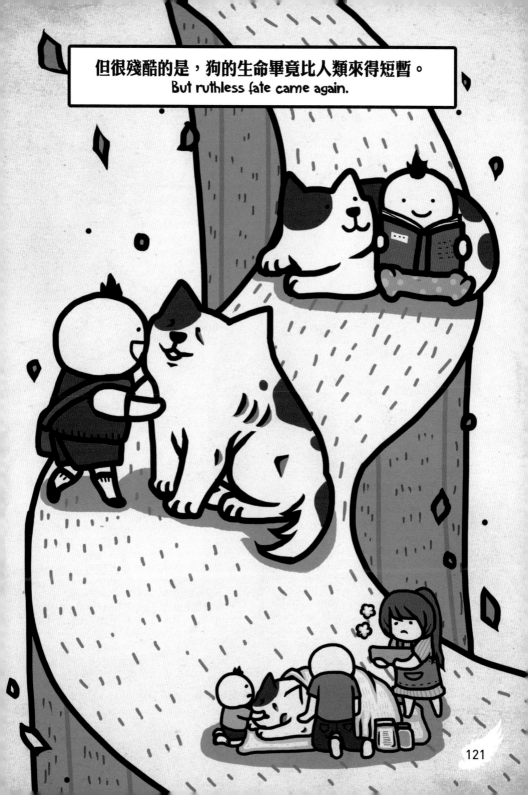

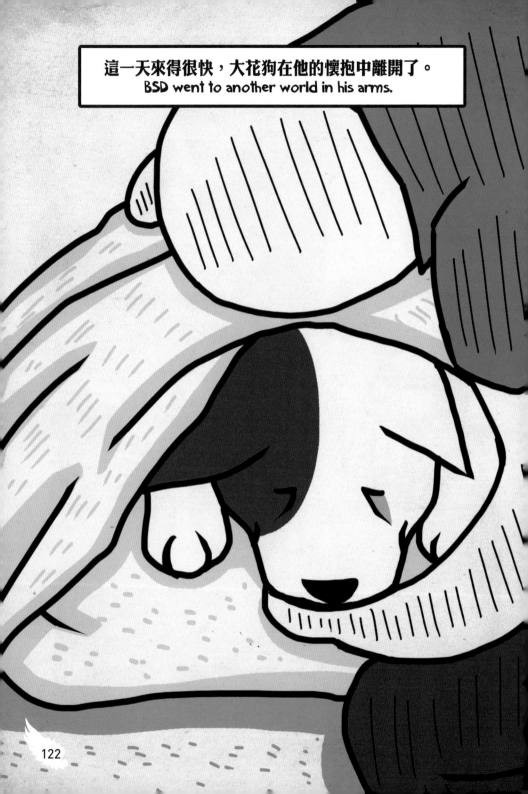

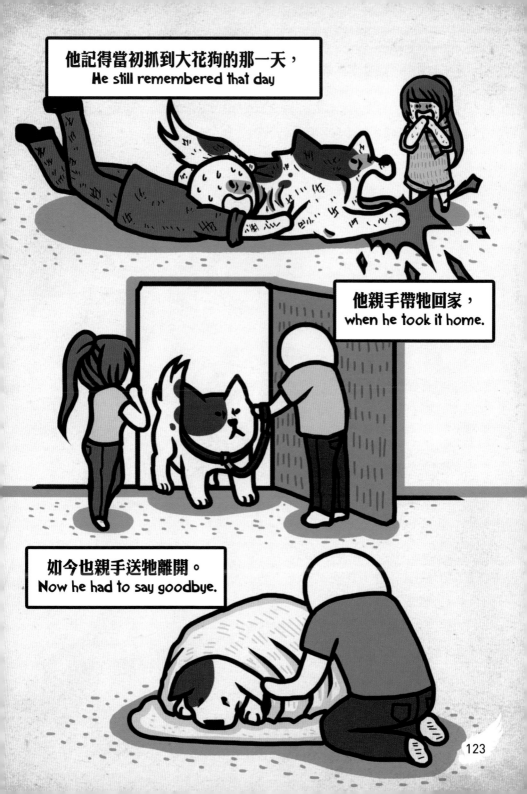

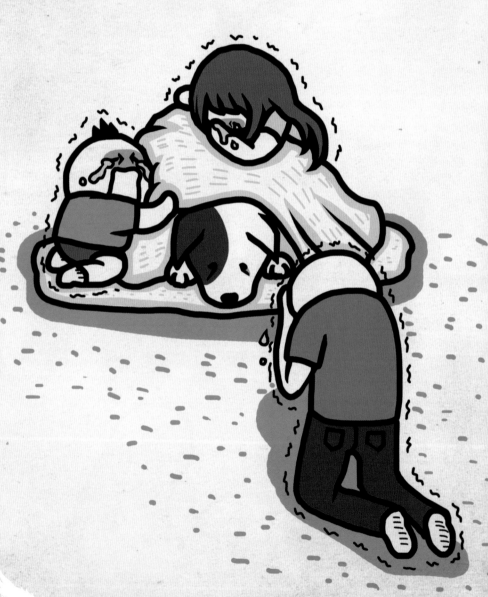

124

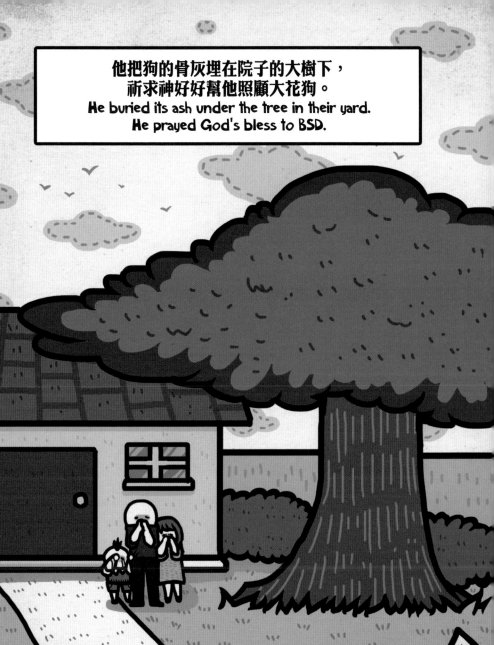

他把狗的骨灰埋在院子的大樹下，
祈求神好好幫他照顧大花狗。
He buried its ash under the tree in their yard.
He prayed God's bless to BSD.

第五章
老年

Chapter 5
Old age

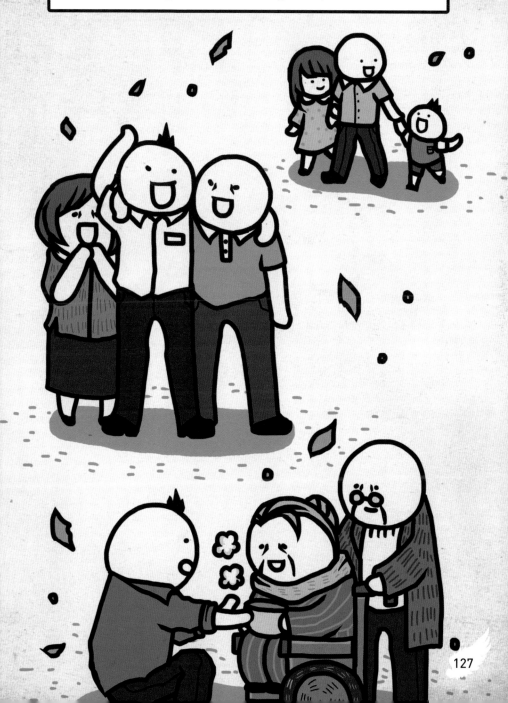

時間過得很快，兒子大了，他和老婆都老了。
He and his wife aged while his son grew up as a decent man.

127

老婆生病了，他陪在老婆身邊照顧她。
She was ill. He did every effort to look after her.

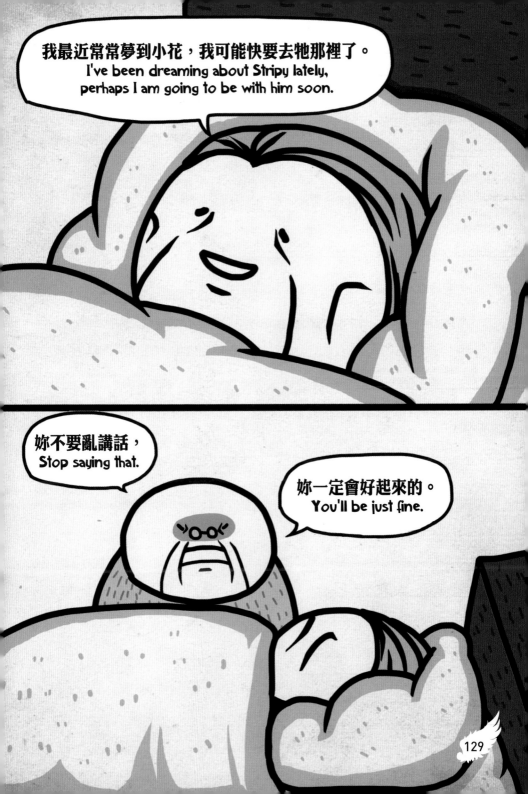

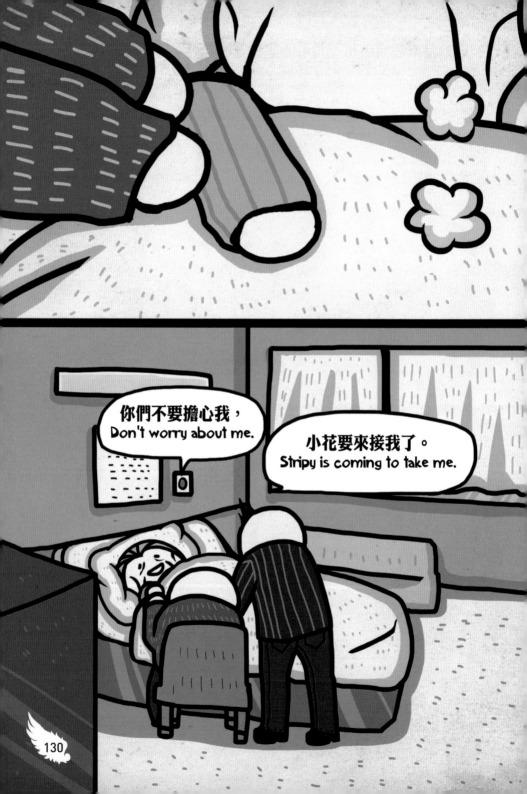

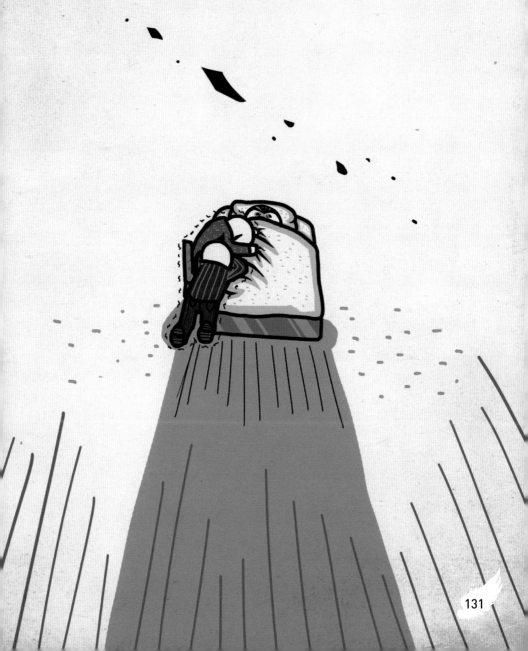

老婆過世了，他和兒子大哭。
She passed away.
Leaving her heartbroken husband and son.

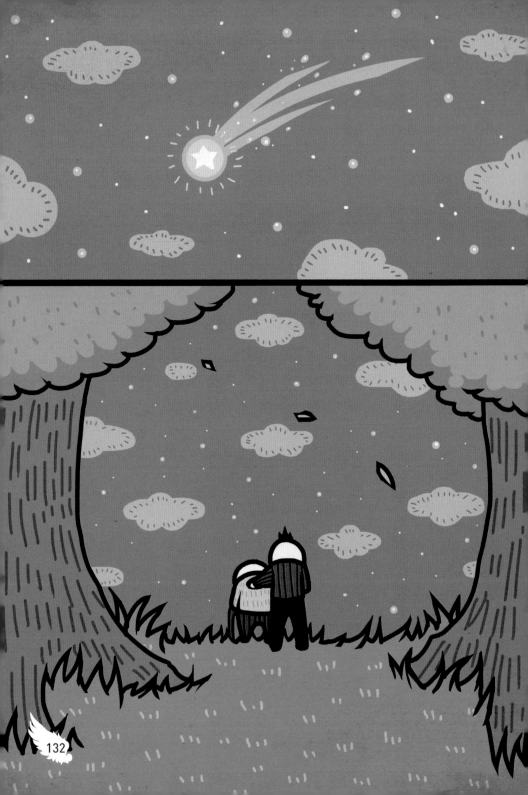

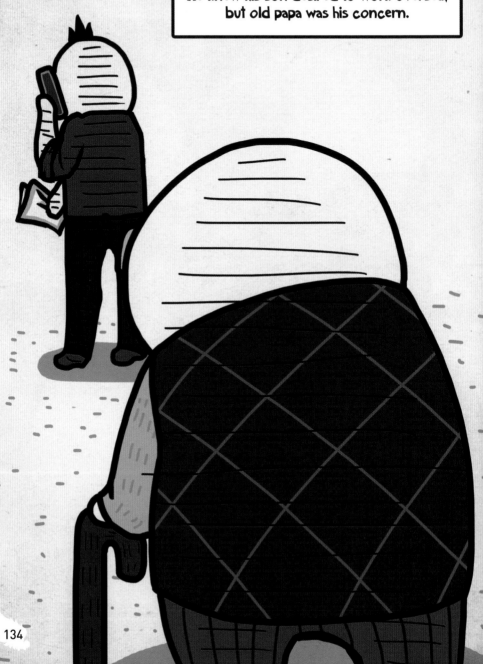

他告訴兒子：「沒關係，想去就去吧！趁年輕時闖一闖。
你就去吧！我還沒老啊，我會等你回來的。」
"It's alright, just go! Explore the world when you are young.
I'm not that old, I will be here for you." he said.

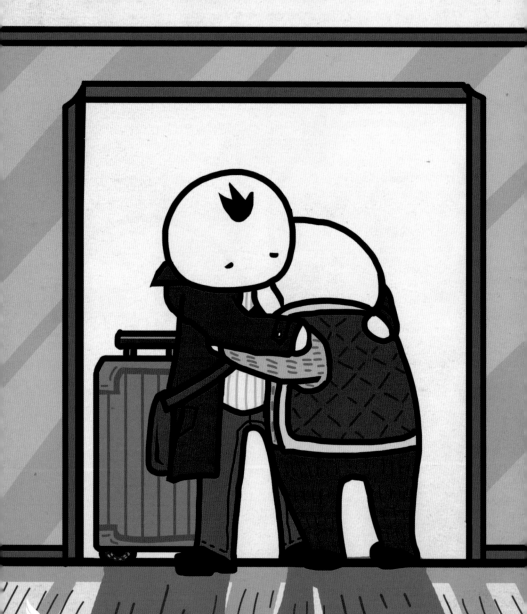

136

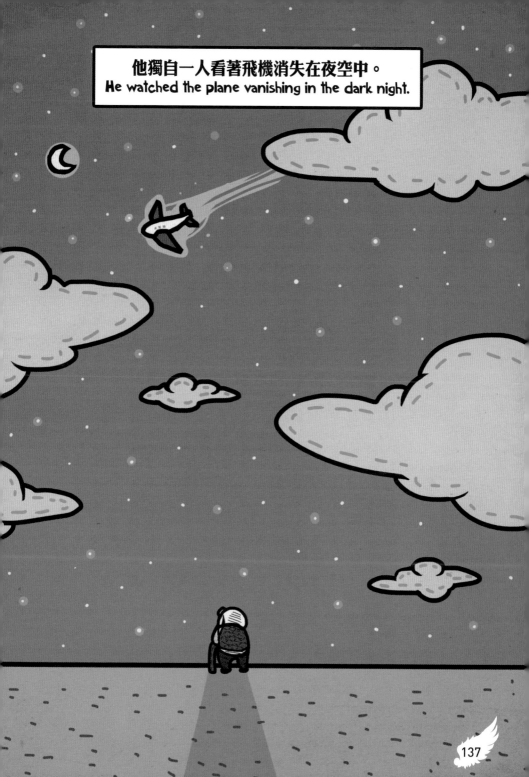

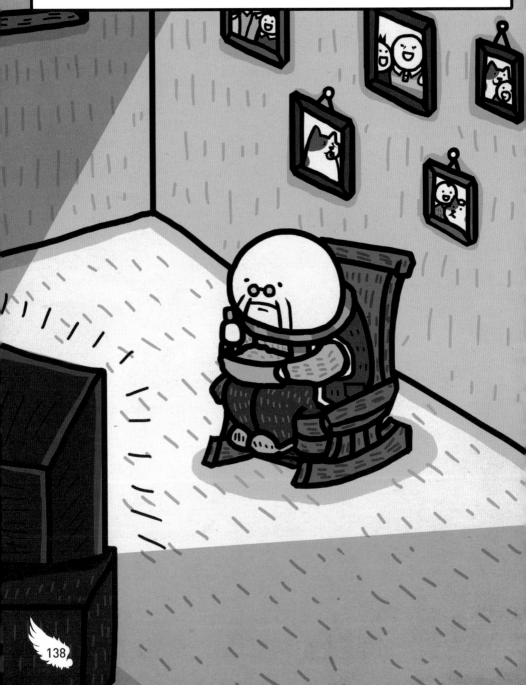

現在家裡只剩下他一個人了，陪伴他的只有牆壁上掛滿的回憶。
He was alone at home, with plenty of pictures and memories.

他知道自己老了，動作也慢了，
身體很多地方都出了毛病，每天總有吃不完的藥。
He knew he was old with many health concerns.
Not being flexible anymore.
He took lots of medicines every day.

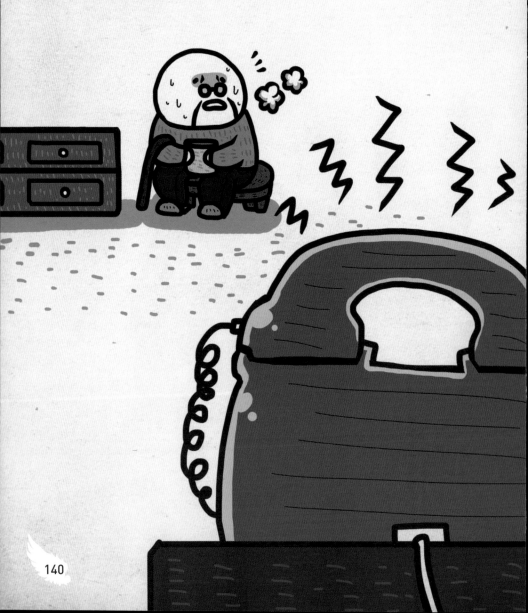

兒子很乖，每隔幾天就會打電話回家問候他。
His son talked with him via phone every few days.

他總是跟兒子說他過得很好，
身體還很勇，叫兒子不用擔心。
"I'm fine, absolutely healthy, no worries!"

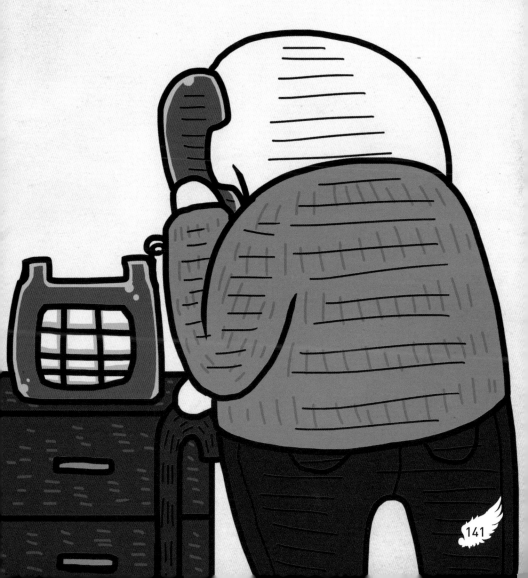

漫長的夜晚只剩下他獨自一人看著過去的照片。
He browsed the old photos every night.

142

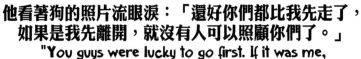
他看著狗的照片流眼淚：「還好你們都比我先走了，
如果是我先離開，就沒有人可以照顧你們了。」
"You guys were lucky to go first. If it was me,
nobody could look after you." His tears dropped.

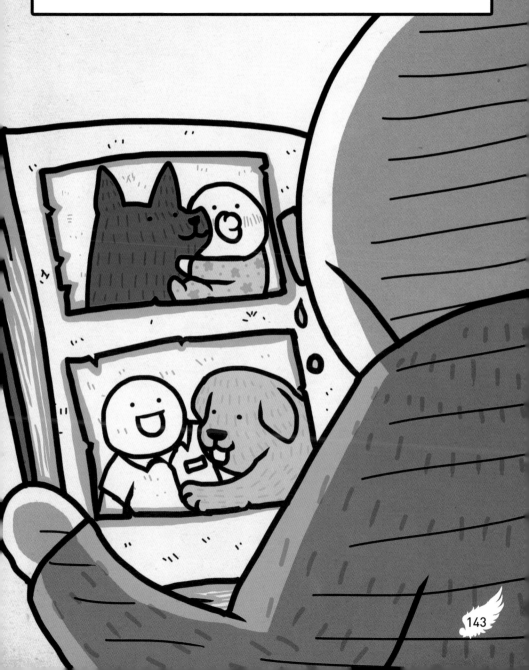

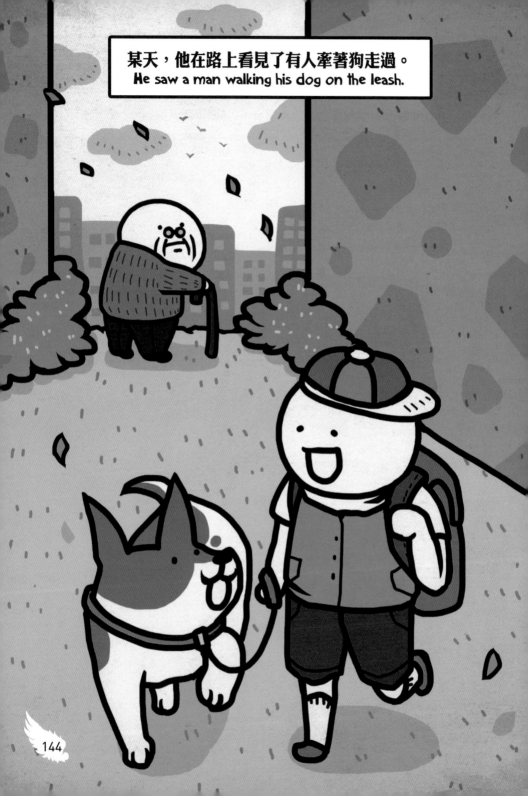

某天，他在路上看見了有人牽著狗走過。
He saw a man walking his dog on the leash.

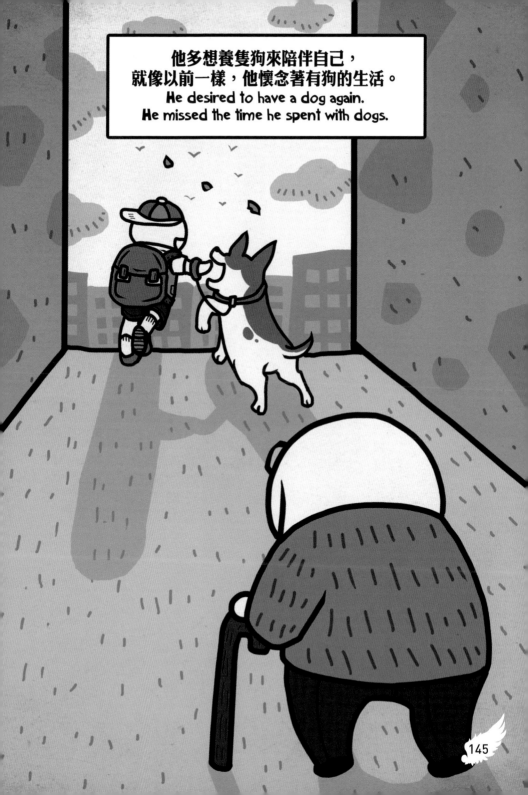

但是他知道自己老了，沒辦法再養一隻狗了。
But he knew he was too old to have a dog.

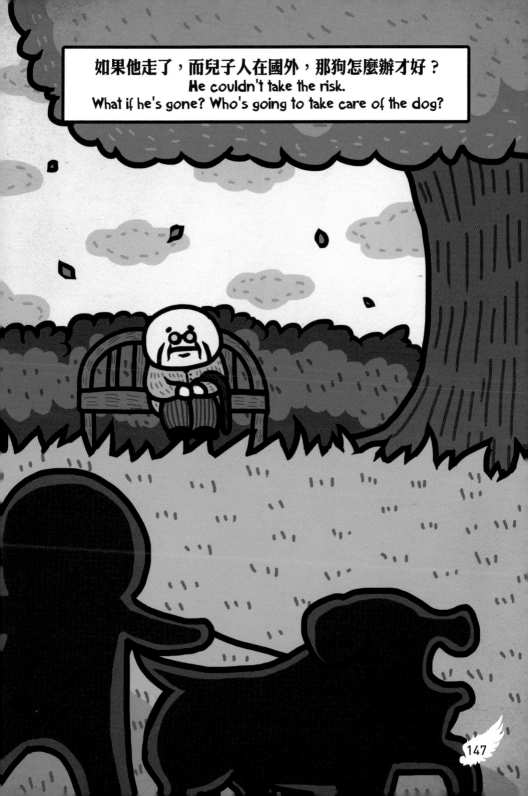

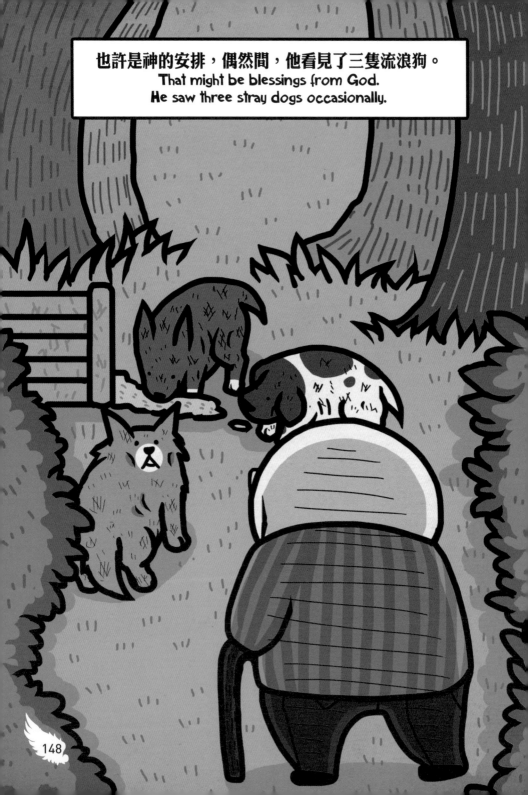

他回去拿了錢包，買了水和飼料跑去餵狗。
He ran to buy the feeds and water for them.

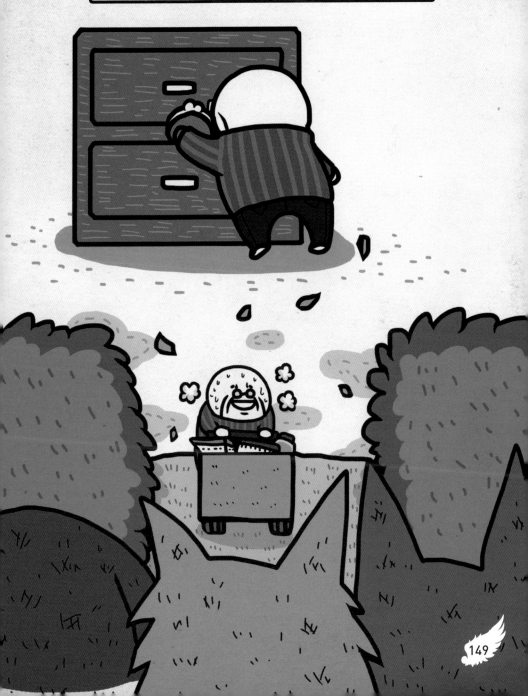

他覺得自己的人生又有了目標，他很快樂，臉上又有了笑容。
He found himself having a life goal again.
He was so happy and there were smiles on his face again.

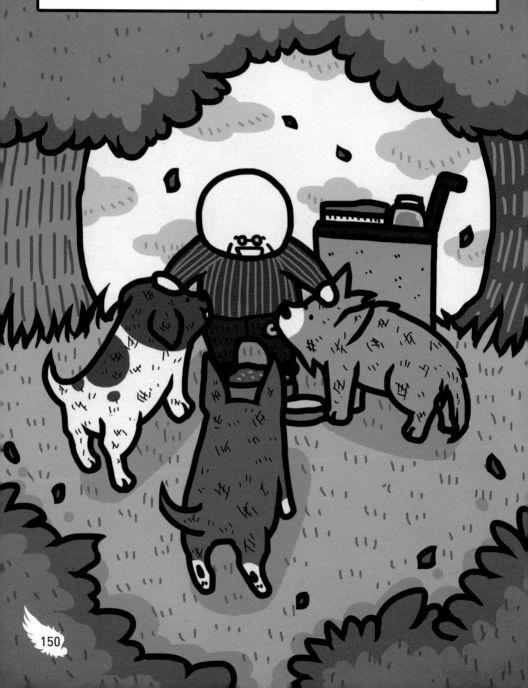

他一隻隻的帶狗去看醫生，
He brought them to the vet.

他每天風雨無阻的去餵那些狗。
He fed them in all weathers.

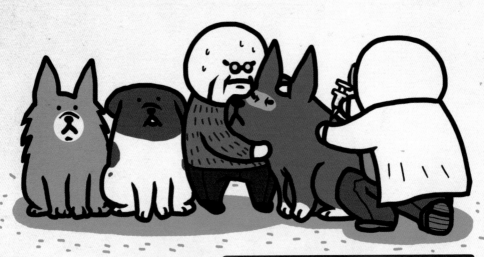

他想幫狗找到好主人，就像以前和老婆一起做的一樣。
He wanted to find them an eternal family,
just like what he used to do with his wife.

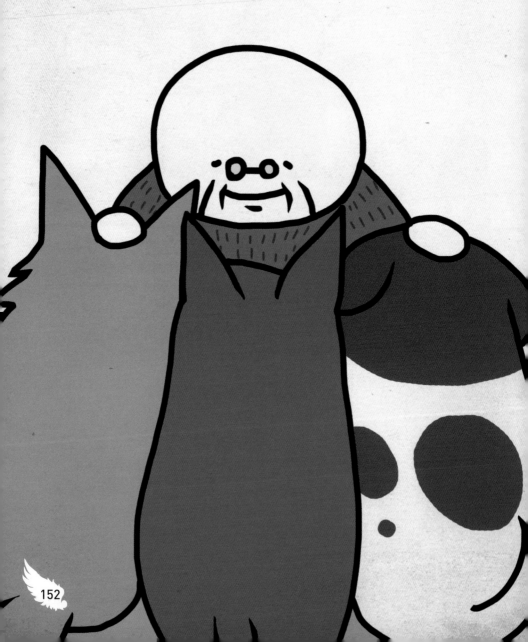

他到動物之家問志工，問到了一些方法，他很高興。
He went to the Animal Shelter and consulted with the volunteer.
He was happy.

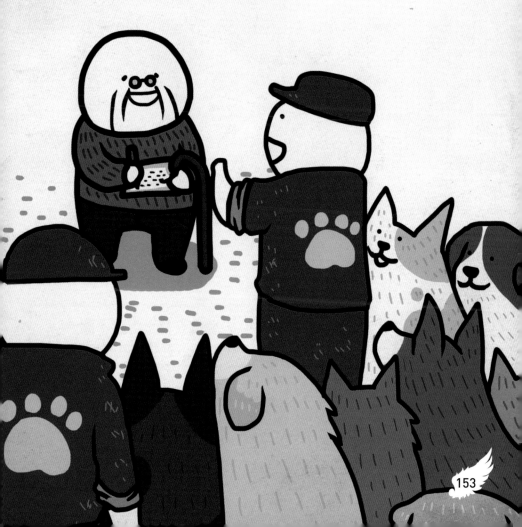

153

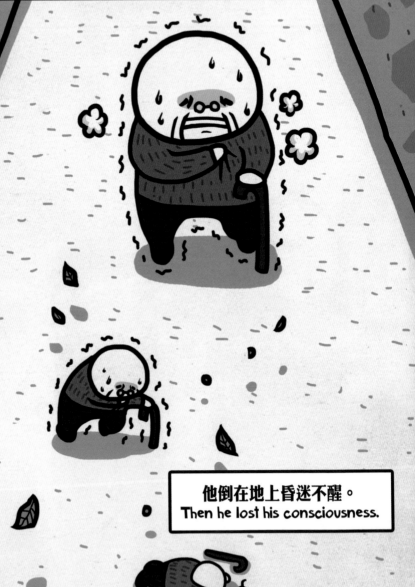

回程途中，他的心臟突然絞痛不已，冷汗不停從他額上流下，
He had a heart attack on the way home.

他倒在地上昏迷不醒。
Then he lost his consciousness.

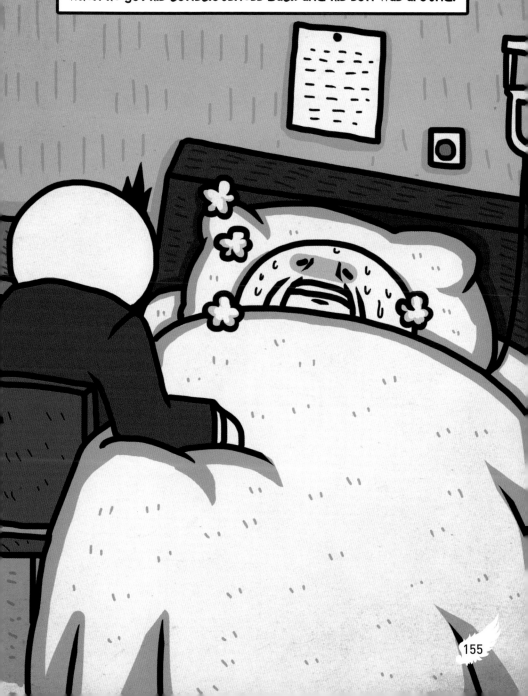
他醒來了，發現自己人在醫院，兒子在他身邊。
He found himself in the hospital
when he got his consciousness back and his son was around.

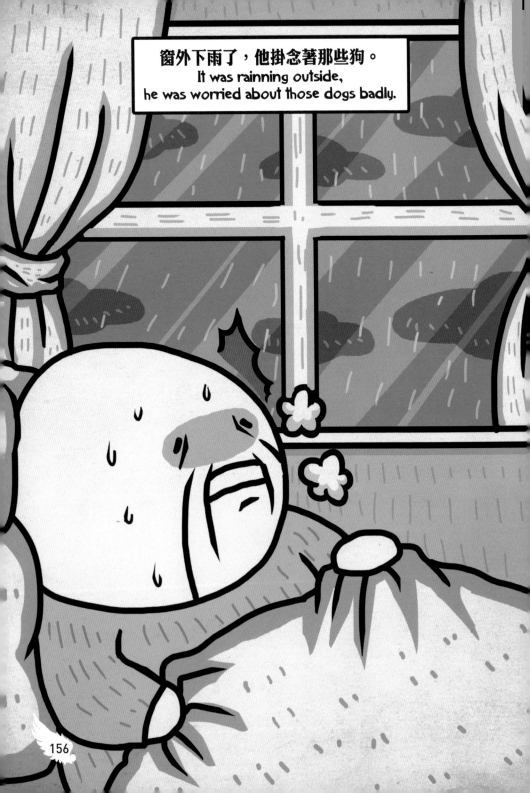

他告訴兒子說他要去看狗，他快幫狗找到家了，
但是兒子堅持不讓他去。
Their forever home was almost there,
he had to take a look at those dogs!
But his son insisted not to let him go.

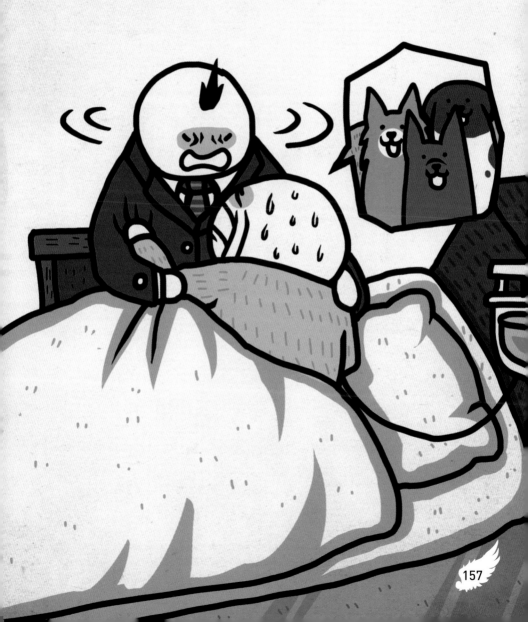

他很焦急，卻被困在醫院裡無計可施。
天空的雨不停的無情落下。
He was anxious. He was trapped in the hospital
and incapable to do anything.
The rain never seemed to stop.

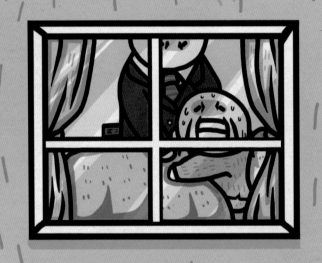

第六章
彩虹橋

Chapter 6
Rainbow Bridge

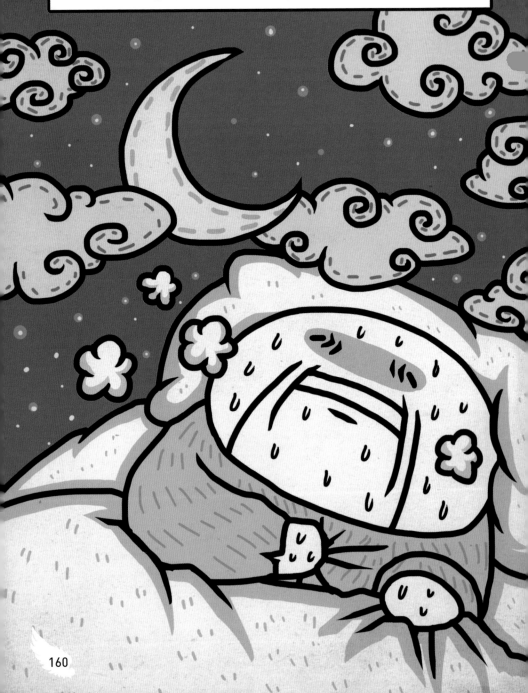

夜晚來臨，他的身體越來越難受，他的心臟痛到快窒息了。
One night, he felt suffocating due to the chest pain.

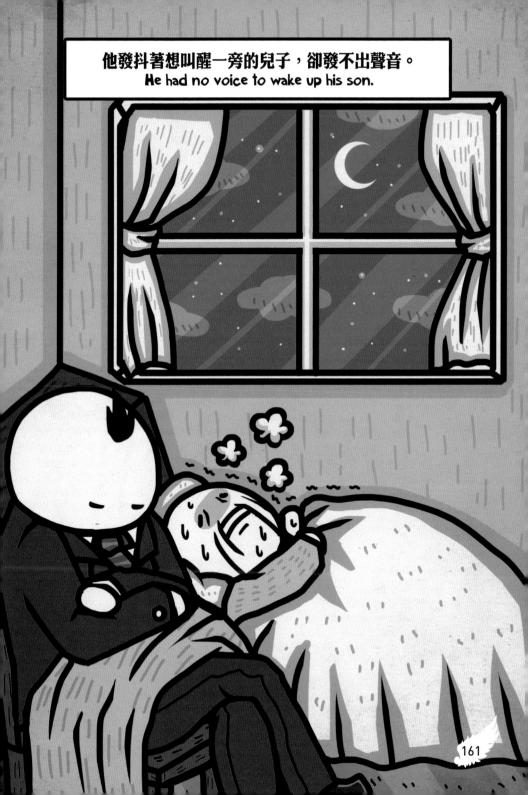

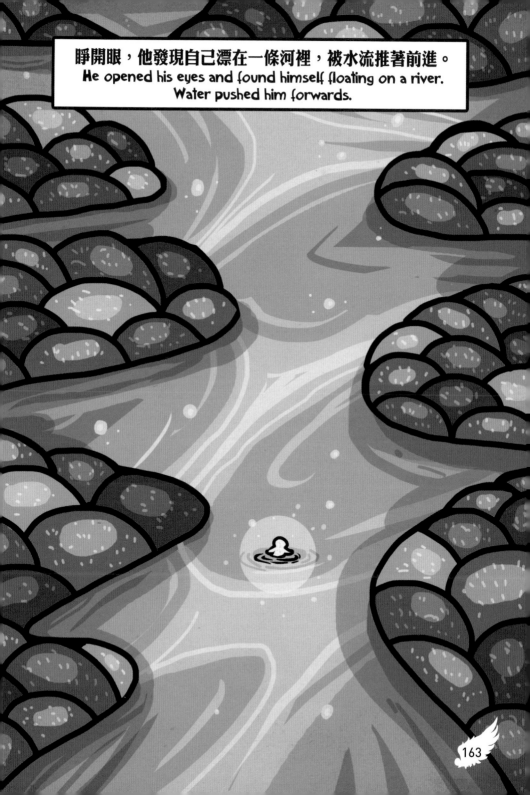

睜開眼，他發現自己漂在一條河裡，被水流推著前進。
He opened his eyes and found himself floating on a river.
Water pushed him forwards.

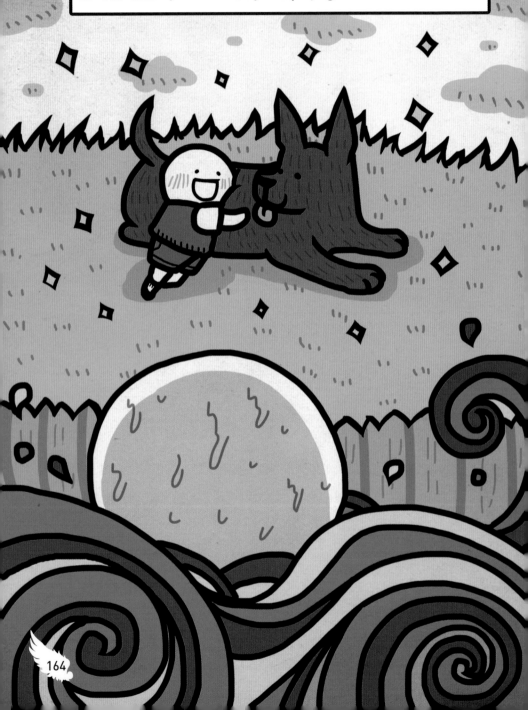

他在岸邊看見小時候的自己在跟大黑狗玩。
He saw himself as a little boy and playing with BBD on the shore.

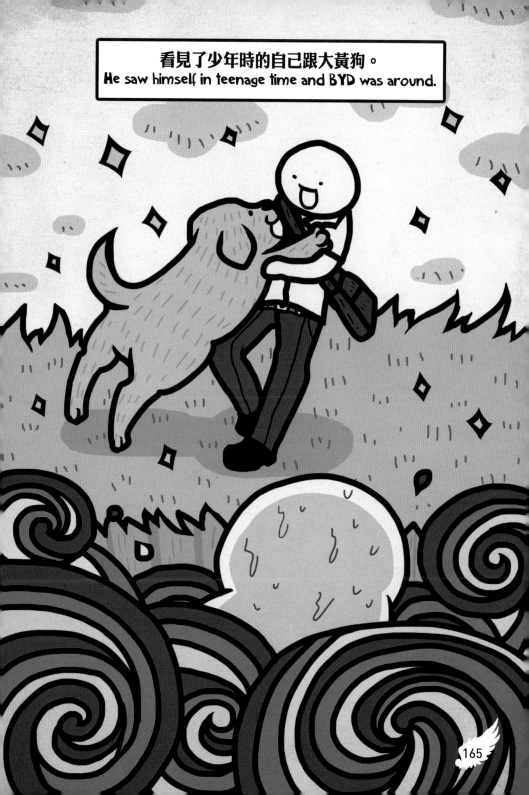

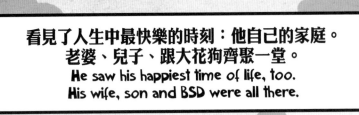

看見了人生中最快樂的時刻：他自己的家庭。
老婆、兒子、跟大花狗齊聚一堂。
He saw his happiest time of life, too.
His wife, son and BSD were all there.

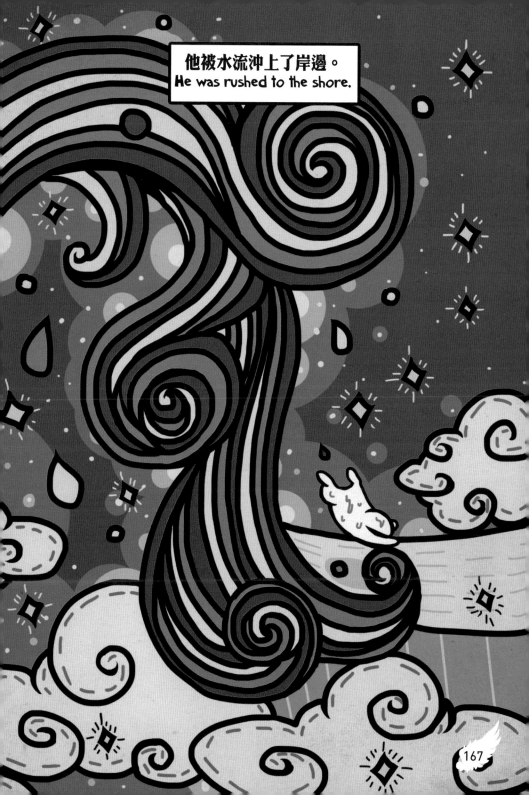

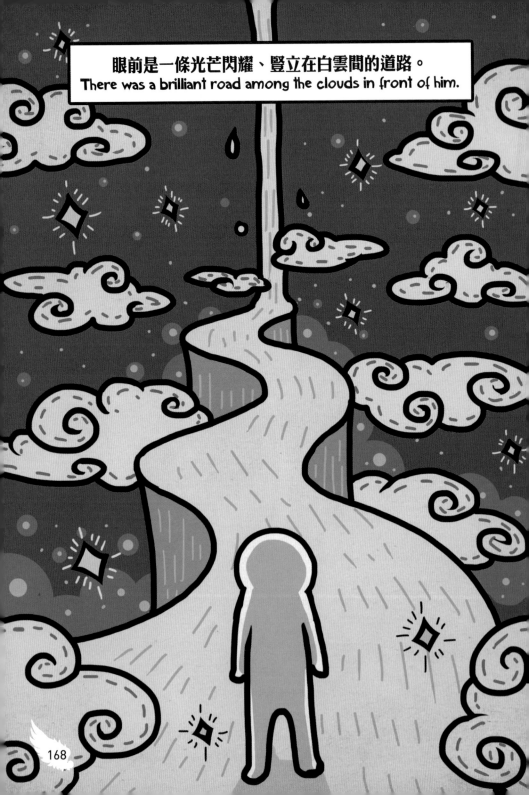

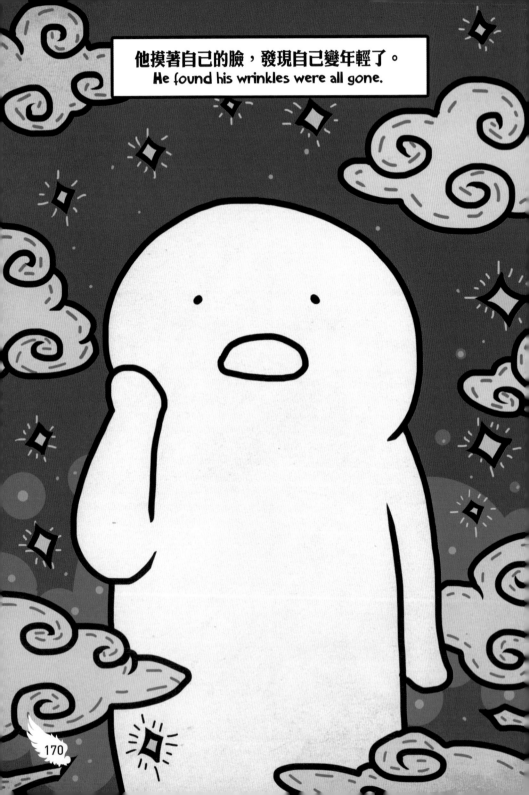

他摸著自己的臉，發現自己變年輕了。
He found his wrinkles were all gone.

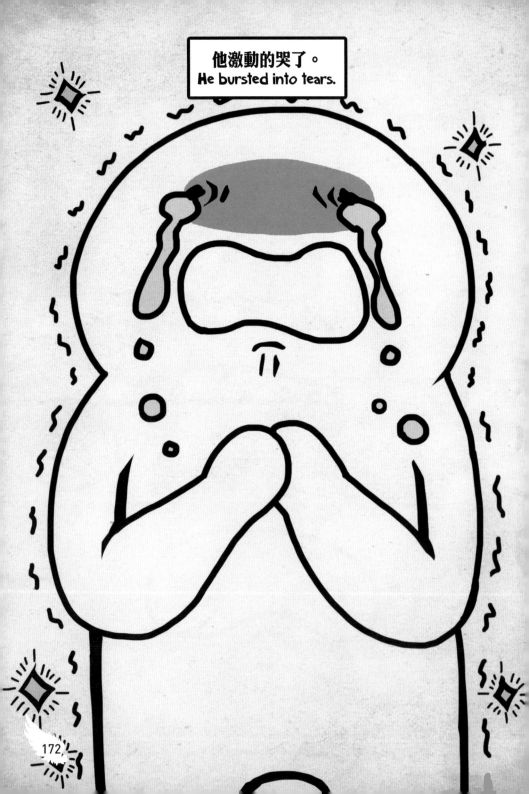

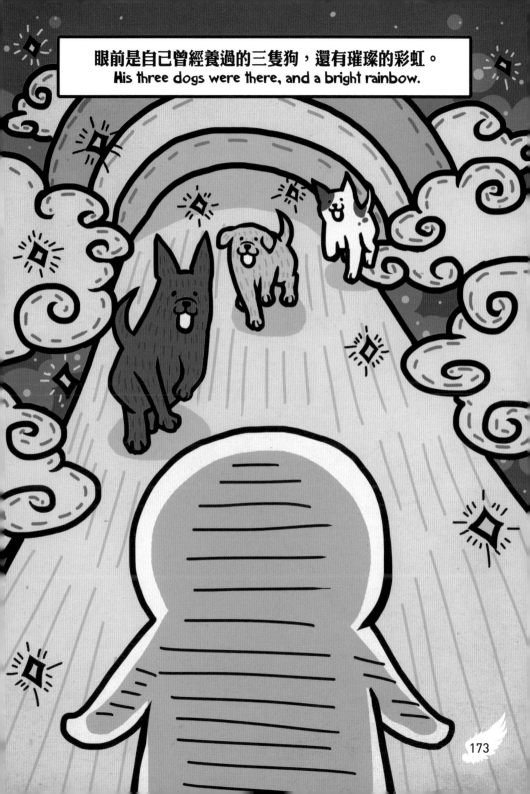

眼前是自己曾經養過的三隻狗，還有璀璨的彩虹。
His three dogs were there, and a bright rainbow.

173

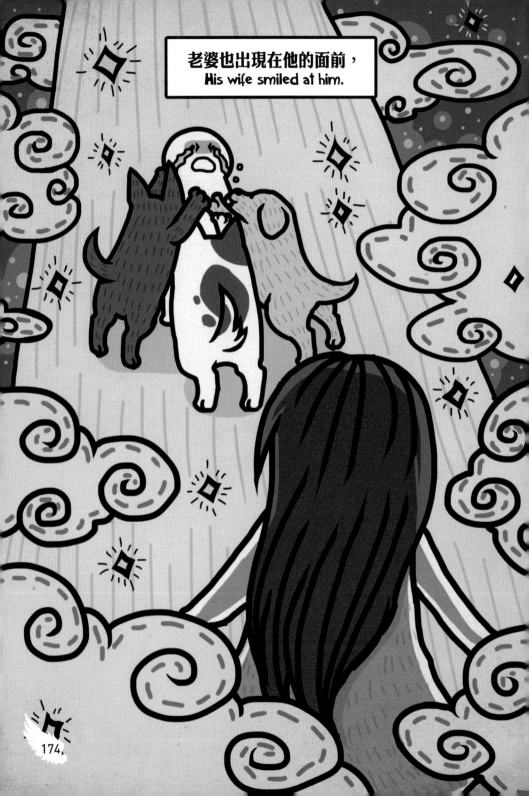

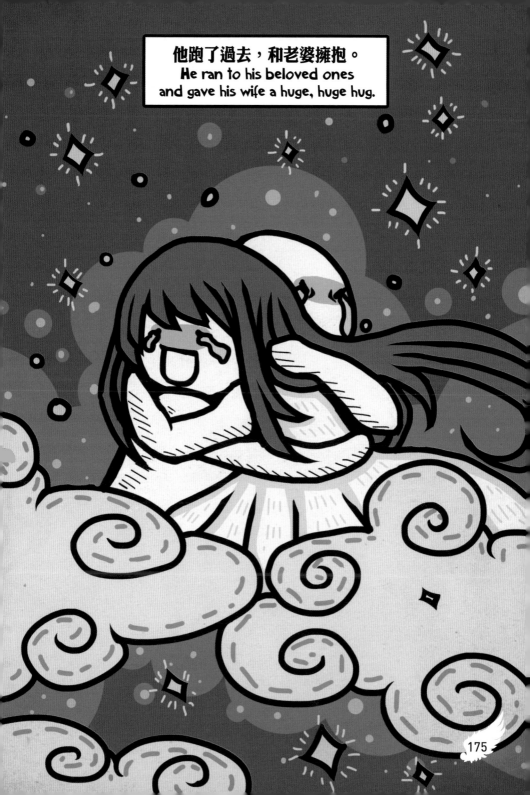

他跑了過去，和老婆擁抱。
He ran to his beloved ones
and gave his wife a huge, huge hug.

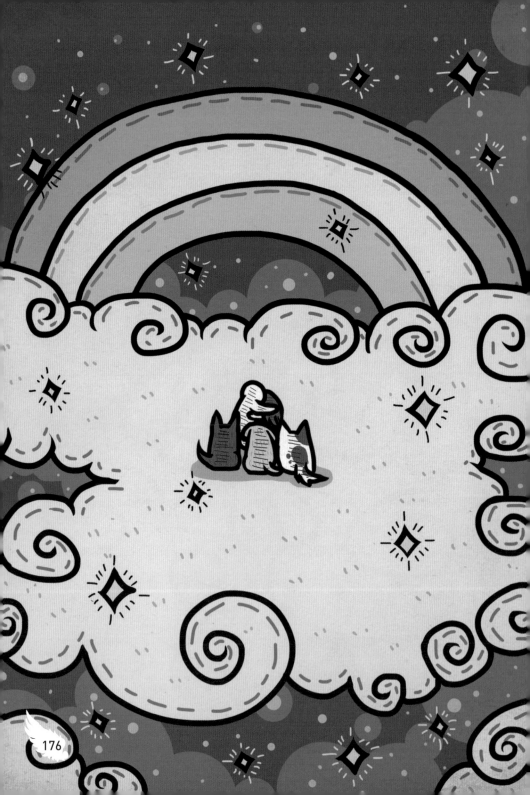

第七章
後續

Chapter 7
Epilogue

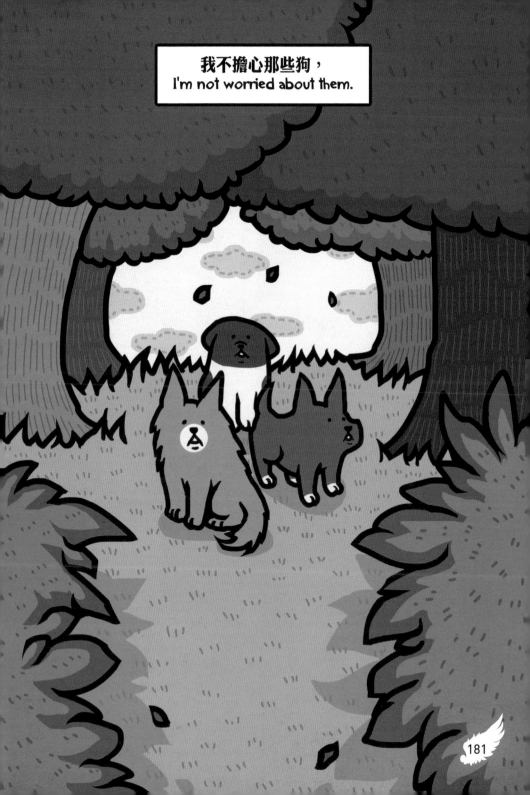

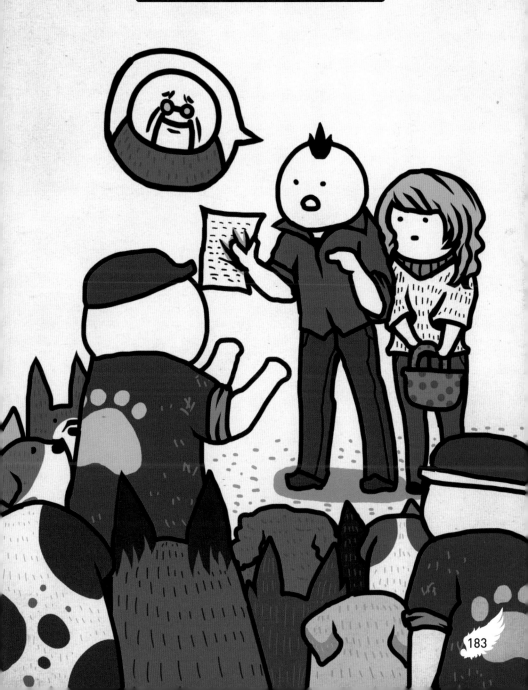

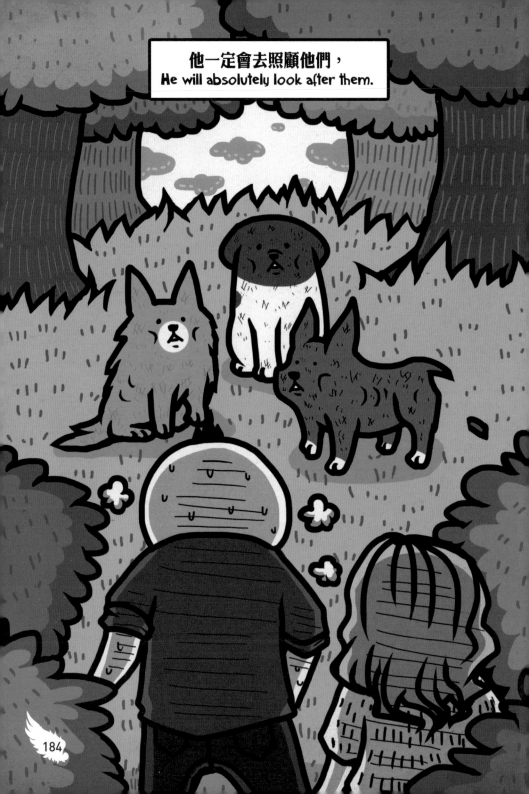